the photographer's guide to Puget Sound & Northwest Washington

Where to Find Perfect Shots and How to Take Them

Rod Barbee

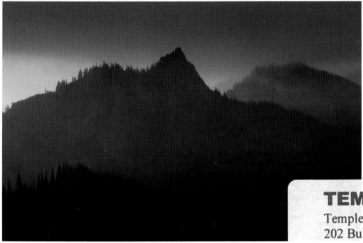

THE COUNTRYMAN PRESS
WOODSTOCK, VERMONT

To my wife, Tracy Rowley, for her support and for putting up with my long absences. And to our "daughter," Bailey, whose wagging tail always greets me when I return.

Text and photographs copyright © 2007 by Rod Barbee

First Edition

ISBN 978-0-88150-756-0

Cover and interior photographs by the author unless otherwise indicated
Cover and interior design by Susan Livingston
Maps by Paul Woodward, © The Countryman Press

Published by The Countryman Press, P.O. Box 748, Woodstock, VT 05091

Distributed by W.W. Norton & Company, Inc., 500 Fifth Avenue, New York, NY 10110

Printed in China by R. R. Donnelley

10 9 8 7 6 5 4 3 2 1

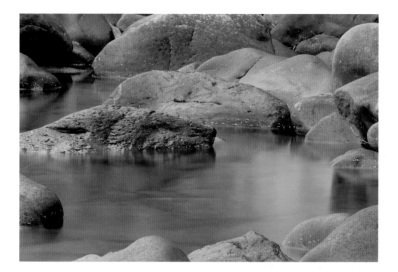

Acknowledgments

I'm lucky to have some wonderful photographers as friends. I've found that photographers, on the whole, are generous and sharing folk. For their help, I'd like to thank Dick Badger, Lise Butler, Tom Layton, David Middleton, Gary Peniston, Shellye Poster, Patrick Reeves, Jackie Smaha, Anne Smart, and Bob Stahl. Some of these offered site suggestions and information, some contributed images, and some provided companionship. All supplied moral support, and for that I thank them all.

Thanks also to Jennifer Thompson at The Countryman Press for keeping the ball rolling. And a big thanks to my editor, Dale Evva Gelfand. She made the editing stage of this project a pleasure instead of a chore, and her input and suggestions make this a better book.

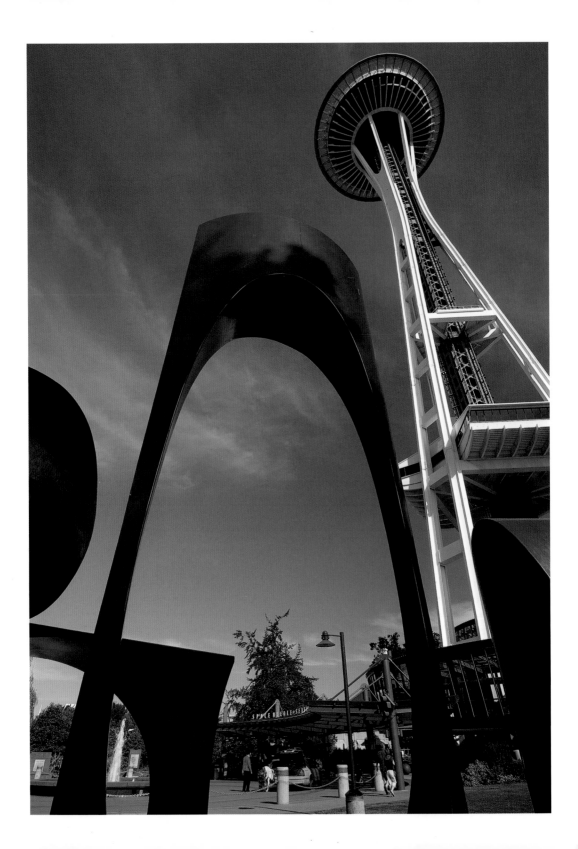

Contents

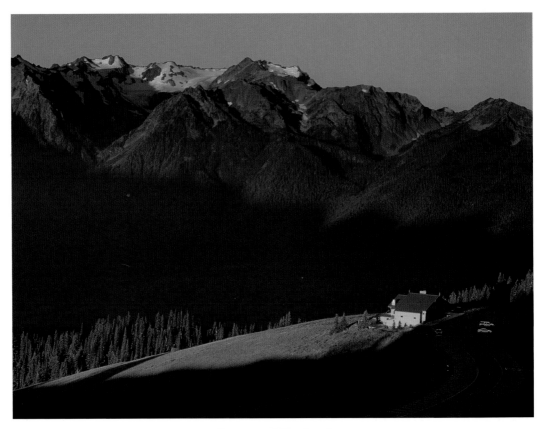

Hurricane Ridge Road

V. The Olympic Peninsula

VI. The San Juan Islands

Introduction

I've lived my entire life in the Puget Sound area. I've visited many other places, but I've yet to find anywhere else I'd rather be. Maybe it's the scenery and mild climate. Maybe it's the West Coast culture and state of mind. Maybe it's just home. In the years since I first picked up a camera, photography has given me an excuse to explore the region more and more. This book is the result of those explorations.

One myth I'll bust right now, at the risk of being booted out of the "Native Washingtonian Society," is that it rains all the time here. It doesn't. (Though ironically as I write this, we're having the wettest November on record.) Yes, we do get considerable rain, but we also get our share of sunny days. And because it's not sunny every day, we may have learned to appreciate those nice days a little bit more. But I'm a person who actually enjoys the rain, which is a good trait to have for a nature photographer.

I also need to admit something up front: I'm not a city person, and I don't particularly like cities. I don't like going into big cities, I don't like driving in them, I don't like the crowds, and I don't like the polluted air. So though I do cover a number of city locations, this book is definitely biased toward nature. This seems appropriate, seeing how this area is known for its natural beauty and number of outdoorsy people who live here. Seattle is the home of REI (Recreational Equipment Incorporated) after all!

But despite my own aversion to cities, I did enjoy visiting a number of city sites with which I was previously unfamiliar. And that brings me to my first photo tip: Become a tourist in your own home town. Just because you can visit a place "any time" doesn't mean you actually will.

Though this book is tipped toward nature sites, I've tried to balance it with what I consider to be photogenic city sites, as well as a few sites that are just plain old fun tourist attractions. I'm sure I may have missed or neglected a few of what may be your favorites. If so, drop me a line, and I'll try to include them in the next edition.

So grab a map, maybe a city guide or two, and use this book to start planning your next photo adventure in northwest Washington.

Wooden boats and reflections

Using This Book

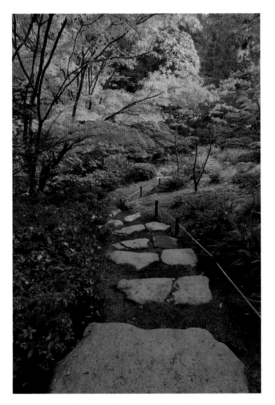

Seattle Japanese Garden

This book is designed to get you to photogenic places at the best times and help you get the best photos you can while there.

The site descriptions give you a general idea of what to expect and even some very *specific* things to expect. Along with the site descriptions, I include information on best times of day to photograph as well as seasonal variations such as sun position, blooming times, and so on. Throughout the book I scatter some site-specific Pro Tips. Those tips that are more generally applicable are gathered in the "How I Photograph" section. I've also listed any cautions, be they physical or photographic, about things you should avoid. After all, if you hurt yourself who's going to buy my books?

I'm going to assume (yeah, I know what they say about making assumptions) that you have either a 35mm or a digital single-lens reflex (SLR) camera—mainly because those are the overwhelming choices of serious photographers. If you're shooting large or medium format, you probably don't need many of the basic tips in this book. If you're taking photos with a point-and-shoot camera, once you're hooked, you'll eventually be getting an SLR.

The lens recommendations I make are most often in general terms—like wide angle or short telephoto. This is due to the different ways lenses behave with different format cameras. And unless you're shooting with a full-frame digital SLR, your digital camera is actually in a different format than 35mm film. For most digital SLR cameras, the sensor is smaller than a piece of 35mm film, so you're essentially cropping out of the middle what you would get with 35mm gear.

So when I say wide angle, I mean about 18–35mm on film and 12–24mm on all but full-frame digital cameras. When I say normal, I mean about 35–70mm on film and 24–50mm for digital. Short telephoto would be about 80–200mm on film and 50–135mm on digital. Telephoto on film is 300mm and longer. With digital, it's about 200mm and longer. Super telephotos are the big 500mm and 600mm lenses, and it really doesn't matter which camera is being used at that point. For those occasions when one zoom lens would serve both formats, I'll usually recommend a specific zoom range.

Finally, use this book to discover and explore Northwest Washington and make your own best images along the way. There is a lot to see and photograph here. From mountains and flowers to harbors and city lights, you won't be running out of subjects any time soon.

How I Photograph Northwest Washington

When I photograph, I look for different things, depending on what my goals are. Because light is so important to photography, I usually first consider the lighting conditions. After that, it all depends on the subject. For landscapes, I look for situations and ways to make connections from foreground to background. When I'm shooting close-ups, I'm looking to combine a great subject with a good background. I often do the same with wildlife. And I treat travel and city photography much the same way I treat landscapes (only I keep a better eye on my equipment).

Light Considerations

Light is a huge part of what photography is about. A great subject in dull light makes for a dull photograph, but an OK subject in fantastic light makes for a great photograph. Learning to evaluate the light is an important part of being a photographer, and it's a learning process. The more pictures you take in dull light, the more you'll realize you don't want to photograph in dull light. The following are my suggestions for what to do when presented with various lighting conditions.

Sunrise and sunset: the magic light. The hour before sunset and the hour after sunrise are usually the best times for landscape photography. These are called the "magic hours." Everybody likes the warm light of sunrise or sunset. The colors are more pleasing, the contrast levels are manageable, and the low angle of the sun creates better side lighting conditions, which reveals texture and adds depth to the image.

Overcast or rainy days are great times to photograph in forests and gardens. Direct sunlight in a forest leads to hideous contrast problems, including dappled light, that make for images that are confusing to the eye and not attractive at all to look at. Cloudy days also work best for streams and waterfalls. Be sure to keep the sky out of the picture, though; it will just record as a bright blank space—a definite distraction. Overcast skies are also best for close-up photography.

Fog or early clear skies work well for harbors. A foggy morning in a harbor has a mysterious feel to it. In addition, fog makes its own non-distracting background. On the other hand, a clear morning in a harbor offers reflections in the water that are hard to beat.

Blue skies with puffy clouds for mountain and lake landscapes. Blue skies by themselves are often just boring, but if you've got the puffies, you've got interesting skies. Puffy clouds look great reflected in a calm lake, too.

Blue skies for daytime city landscapes. Let's face it, a city with dull gray skies behind it is a dull-looking city—especially here in the northwest. Try to use the northern sky when possible because the sky is bluest to the north.

Twilight for city landscapes. For about a half hour after the sun sets or before it rises, the sky photographs as a deep purplish blue. And it doesn't matter if the sky is clear or cloudy. Combine this with city lights, and you'll have some winning shots.

Winter skies. During winter at this latitude, the sun is always low in the southern sky. On blue-sky days, this makes for bright southern skies and backlighting conditions. This is especially evident if you try to include Mount Rainier in

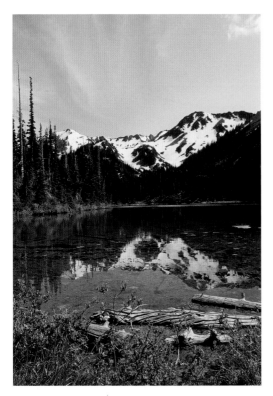

*Example of a bad foreground
and a poor background*

*Example of a good foreground
leading to a good background*

just about any of your shots, since Mount Rainier is south of just about everything in the Puget Sound area. For these landscapes and cityscapes, it's best to photograph early to mid-morning and midafternoon to sunset.

Of course, with the sun always low in the sky, this means you have a lot of nice low side lighting all day, especially in the morning and late afternoon. This effectively stretches out the "magic hours."

Landscape Tips

Get close and low to your foreground. Make the picture more about what's going on around you, and use the background (a mountain, a building, the sunset sky) as backdrop to your foreground. The trick is in finding an interest-ing foreground, one that leads the viewer through the frame and to the background. I always think about stepping stones. I look for foreground elements—be they flowers, rocks, tidal pools, bushes, trails, or whatever—and then try to connect these elements so that the eye travels naturally from one to another.

Tell a story. A good landscape photo is a visual journey with a start (foreground), a middle (midground), and an end (background).

Use hyperfocal technique with wide angle landscapes. This will ensure sharpness from foreground to background.

Understand exposure. Many landscape scenes contain a range of light that is beyond the ability of film or sensor to record. Learn to

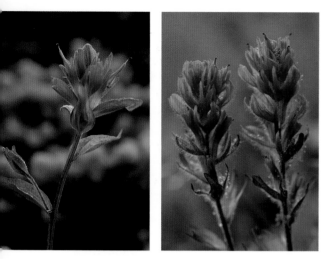

Left: Example of a bad background—Indian paintbrush with a distracting background; Right: Example of a good background

recognize these situations and to mitigate them using graduated neutral-density (ND) filters or by blending multiple digital captures.

Always use a tripod. A tripod enables you to use slower shutter speeds, allows you to fine-tune compositions, and improves your image quality.

Flower and Close-up Photography Tips

Have a way of getting close. This means a macro lens, extension tubes, or a zoom lens with diopters.

Use a tripod and cable release. Quality flower photography requires steady support. You may be using shutter speeds longer than one second at times, and you can't do that without a tripod. And a cable release eliminates unnecessary vibrations.

Use a diffuser. On sunny days, harsh light and shadows make for annoying distractions and can suck all the color out of your pictures. Use

a diffuser to modify the light; it's like having an instant cloud.

Use a reflector. This will add light where it's needed.

Use mirror lock-up. If your camera has this feature or a shutter delay feature, use it. This will help eliminate movement caused by mirror slap.

Pay attention to your backgrounds. Backgrounds are the most important part of a flower portrait. Look for subjects that have good backgrounds. A good background can be one that is relatively far away or one that has very little detail. Also use wider apertures to help decrease depth of field, making your background more out of focus. Use your depth of field preview button to detect any problems in the background.

Look for a good subject. A great background and great light are wasted on a less-than-pristine subject. There are lots of flowers out there. Go find a good one.

Travel and City Photography Tips

Look for attractive settings, and wait for your subject. Find something interesting—a colorful awning, a fountain, a statue—and wait for someone to walk into the setting.

Use landscape techniques. Find interesting foregrounds to give the scene depth and context. Use hyperfocal techniques when possible.

Use image stabilizing (IS) or vibration reduction (VR) lenses. Let's be realistic: Tripods are often impractical and inconvenient for travel photography. Image Stabilization and Vibration Reduction lenses (also found in some camera bodies) make this type of photography a lot easier.

Conditions

Yep, it rains here—though not as much as some would have you believe. Don't be afraid to photograph in the rain. Some of my very best forest and stream pictures have been taken in the rain.

Generally speaking, if you can take the weather, so can your camera gear. I keep a shower cap and a backpacking towel in my camera pack to cover or occasionally wipe off the camera and lens and use an old gaiter to cover my longer lenses. Other than that I don't go to any great lengths or employ any specially made rain covers.

Spring, summer, and fall are generally the best seasons here. Frankly, the winter is mostly wet, windy, and gloomy. It's dark by 4:30 or 5 PM and doesn't get light again until 7:30 or 8 AM. This is the season when I work on my catch-up list of things to do (I'm still catching up to 1997).

The Puget Sound area itself doesn't get much snow. For that you need to head to the mountains. Occasionally, high-pressure systems come in, making for gloriously clear skies. It also gets pretty cold then, too. These are the times to head for Hurricane Ridge or the winter birding areas of the northern sound.

Some General Cautions

There isn't a whole lot to be worried about here. There is a lot of coastline along Puget Sound and the Olympic Peninsula. Rocks and seaweed are slippery, and the footing can be dangerous. Also, keep an eye to the tide, especially if you're out at the ocean or near a place where a high tide can cut you off. Mountains have some steep and rough terrain, and streams and rivers can be slippery, as well.

The greatest danger is probably just driving around the Puget Sound metropolitan areas—which, if you read my introduction, you know I avoid as much as possible.

Equipment

Tripods: I make every photograph I possibly can from a sturdy tripod. Without a tripod you can't make stream pictures with that smooth, flowing look to the water. Without a tripod it's difficult to make landscape images with sharp foregrounds and in-focus backgrounds. A tripod will slow you down and allow you to really think through your composition. In short, a tripod is the very best way to improve your photography.

However, sometimes it's impossible or inconvenient to use a tripod. For instance, don't use a tripod on a ferry. The engine vibrations will go right into your camera. Also, some places don't allow tripods, and some places may be too crowded for a tripod to be practical. In these cases, a monopod may be the best answer. I'll point some of these places out in the site guides.

Polarizing filters: The Puget Sound area is a marine environment. It also rains here, and the vegetation is lush. We also get wonderful blue-

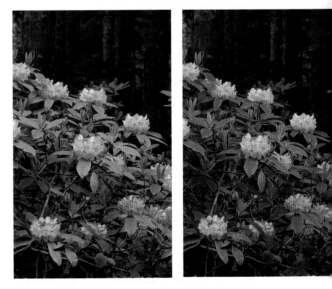

Left: Wild rhododendron without polarizer
Right: with polarizing filter

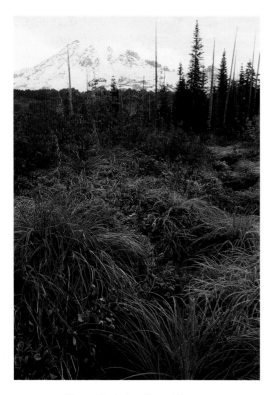

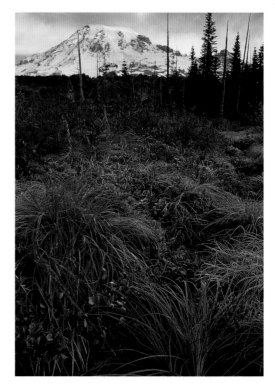

*Mount Rainier shot without a
graduated neutral-density filter*

*Mount Rainier shot with a
graduated neutral-density filter*

sky days. All this adds up to a polarizer. I know, that's some pretty strange math.

Polarizers, when properly rotated, filter out reflections, haze, and glare. You may use one to help darken the sky or remove harsh glare from water or windows. I mainly use a polarizer when photographing forests, streams, or gardens on rainy or cloudy days. A polarizer not only darkens skies, it cuts glare coming off leaves and rocks, allowing the true color to show through. A polarizer is how you get those lush green rainforest pictures.

How do I determine when to use a polarizer? I simply hold one up to my eye and rotate it. Make sure the filter threads are pointing at you, just as if they were mounted on your lens. If I see something I like (often referred to as the "Oohh Factor"), I then attach the filter.

Graduated Neutral-Density Filters: Since neither film nor digital sensors can record the same range of light our eyes can see, they can't be expected to faithfully record every scene. Sometimes they need help. Grad ND filters are rectangular pieces of glass or optical resin, half dark and half clear. They can be used to darken a part of the scene, allowing film or sensor to better capture the entire range of light. I usually use them when the foreground is shaded and the background is lit, which often happens around sunrise and sunset.

Grad ND filters come in different strengths to handle different exposure situations and they take a little practice to learn how to best to use them. If you're a film shooter, you most definitely need to have a few. If you're a digital shooter, grad NDs come in handy but are not

always necessary; there are ways to combine two or more exposures of a scene into one properly exposed final image. I shoot both film and digital and I use grad ND filters all the time for both formats.

Other filters: I only use two other filters: a warming filter and a neutral density filter.

Warming filters are used to counteract the blue light from the sky when photographing on a sunny day in the shade. If you're a film shooter, a warming filter in the 81 series is essential. Digital shooters can simply set the white balance control on the camera accordingly.

The other filter I use is a neutral density filter, not to be confused with a graduated neutral density filter. ND filters are round and screw on just like any other filter. These filters reduce the amount of light reaching the film without effecting color (hence, they're neutral). They come in a variety of strengths from one stop to four stops, or even more. I often use them to further slow the shutter speed. There are some really creative things you can do with long shutter speeds like smooth out ocean waves to make misty, ethereal images. I use them more and more with digital cameras. When I shoot film, I often use 50 ISO Velvia slide film, and attaining slow shutter speeds is rarely a problem. With digital cameras, often the slowest ISO is 200. A two-stop ND filter gets me back to the shutter speeds I'm able to use with a 50 ISO film.

Lens hoods: You may have noticed that I haven't mentioned protective, or skylight, filters. I don't use them. Instead, I use a lens hood to protect the lens while I'm shooting. If I'm not shooting I put the lens cap on. Lens hoods protect from stray light, rain, and the occasional rock or tree. If I need to protect the lens from something (like salt spray, blowing sand, a dog's nose) then I'll put a filter on, but otherwise I don't use protective filters.

Lens flare is the fiendish culprit that is mainly responsible for loss of image quality. Any direct light striking the front element of a lens, or the filter, can cause lens flare. Lens flare can take the form of bright visible shapes, usually one or more roughly circular highlights, or more subtly, it can cause an overall loss of contrast.

So use a lens hood. Next to a tripod, this one piece of equipment will improve picture quality the most.

Diffusers and reflectors: Shooting close-ups on bright, sunny days is usually not the best choice since you'll be dealing with lots of highlights and shadows, resulting in blotchy, confusing images. Both film and digital can record only a narrow contrast range, and those highlights will be detail-less white areas, the shadows will be detail-less black areas, and colors will be washed out. Fortunately there's an easy fix for this: the diffuser.

Diffusers are pieces of translucent white nylon, usually mounted on a metal hoop. By placing the diffuser between the subject and the sun, you'll soften the light and dramatically reduce the contrast range in the image, enabling the film to record all the details.

Reflectors can be used to add light to your subject. Reflectors usually come in white, silver, or gold and are often mounted on a hoop, just like a diffuser. You can easily make your own reflectors by gluing foil to a piece of cardboard. Crumple, then flatten the foil first. This makes for a softer reflection.

The great advantage of reflectors is that you can see the results before you press the shutter. Diffusers and reflectors can also be used together, one to soften the light, the other to add a little light where needed.

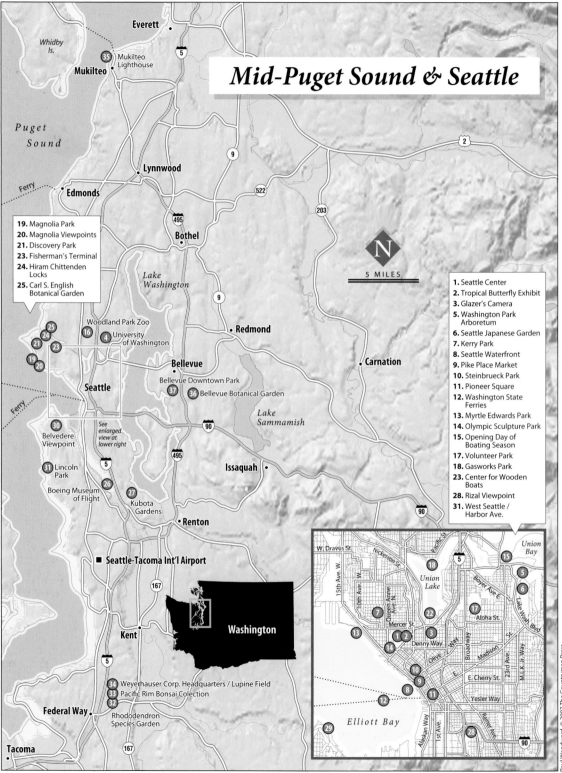

Mid-Puget Sound & Seattle

N

5 MILES

19. Magnolia Park
20. Magnolia Viewpoints
21. Discovery Park
23. Fisherman's Terminal
24. Hiram Chittenden Locks
25. Carl S. English Botanical Garden

1. Seattle Center
2. Tropical Butterfly Exhibit
3. Glazer's Camera
5. Washington Park Arboretum
6. Seattle Japanese Garden
7. Kerry Park
8. Seattle Waterfront
9. Pike Place Market
10. Steinbrueck Park
11. Pioneer Square
12. Washington State Ferries
13. Myrtle Edwards Park
14. Olympic Sculpture Park
15. Opening Day of Boating Season
17. Volunteer Park
18. Gasworks Park
23. Center for Wooden Boats
28. Rizal Viewpoint
31. West Seattle / Harbor Ave.

Puget Sound

Whidby Is.

Everett

Mukilteo Lighthouse
Mukilteo

Lynnwood

Ferry
Edmonds

Bothel

Lake Washington

Woodland Park Zoo
University of Washington

Redmond

Seattle

Bellevue
Bellevue Downtown Park
Bellevue Botanical Garden

Carnation

Lake Sammamish

See enlarged view at lower right

Belvedere Viewpoint

Lincoln Park

Boeing Museum of Flight

Kubota Gardens

Renton

Issaquah

Seattle-Tacoma Int'l Airport

Washington

Kent

Weyerhauser Corp. Headquarters / Lupine Field
Pacific Rim Bonsai Collection
Rhododendron Species Garden

Federal Way

Tacoma

W. Dravus St.
Nickerson St.
Pacific St.
Union Bay
W. Dravus St.
15th Ave. W.
10th Ave. W.
Queen Anne Ave. N.
Union Lake
Mercer St.
Denny Way
Olive Way
Broadway
Madison
Aloha St.
Lake Wash Blvd
Boyer Ave E.
23rd Ave
M.L.K. Jr. Way
E. Cherry St.
Yesler Way
Rainier Ave
Elliott Bay
Alaskan Way
1st Ave.

Paul Woodward, © 2007 The Countryman Press

I. Mid-Puget Sound

The mid-Puget Sound area is the most populous in the state, and for the purposes of this book, I'm loosely defining it as the area on the east side of Puget Sound just north of Tacoma to the area just south of Everett. Here you'll find the largest cultural center as well as most of the major tourist attractions in western Washington. There are gardens, public art displays, harbors, museums, centers of industry, modern cities, and scenery that's hard to beat.

Greater Seattle

Seattle: Birthplace of Boeing, Starbucks, Microsoft, grunge. Home to the Space Needle, the University of Washington, and the Fremont Troll. Here we brag that the Seattle Mariners share the Major League record for most wins in a season while trying to forget that they would have broken that record had they not, on August 5 of that year, tied the record for blowing the biggest lead.

The Seattle area takes up a rather large geographic region, with a wide variety of photographic subjects from cityscapes to streams, from ferries and old airplanes to world-class gardens, from manmade mechanical wonders to strictly touristy travel subjects.

I didn't include every single tourist site you could possible photograph. That would turn this into a Seattle tourism guide. If you want to check out some more of the popular tourist sites, I suggest picking up one of the many guides to Seattle. I've listed a few in the "Additional Reading" section in the back of the book.

Seattle Center (1)

Within the 87 landscaped acres that comprise Seattle Center are museums, concert halls, gardens, a monorail, and one of the most recogniz-able icons in the county, the Space Needle. Watch any television show or movie, and if you see the Space Needle, you know you're in Seattle. Built for the 1962 World's Fair, the Space Needle is one of the top tourist attractions in town. Ride to the top for stunning views of the surrounding city, Puget Sound, the Cascades, Olympics, and of course, Mount Rainier.

Wander around Seattle Center's grounds for different views of the Space Needle. There's no end to foregrounds, sculptures, or other buildings to include in the shot. The **Experience Music Project (EMP)** is just to the north of the Needle. This uniquely shaped, multicolored, metal-skinned museum offers plenty of opportunities for reflections, colors, and abstract shapes. From near the entrance on the north side of the EMP you can get shots of the Space Needle and its reflection on the museum's walls. Cross Fifth Avenue to get a nice shot of the EMP with the Space Needle behind.

Just south of the Space Needle is a large tubular orange sculpture. Use a wide-angle lens to photograph this sculpture with the Space Needle peeking up in the background.

Be sure to visit the International Fountain between Key Arena and Memorial Stadium. On hot days you can photograph kids playing in the fountain. At night, lights at the base of the fountain add a colorful touch. Place Key Arena or the Space Needle in the background for a distinctly Seattle shot.

On the south side of the Seattle Center is the **Pacific Science Center**. You'll be able to see the distinguishing arches from a long way off. These arches make great subjects. Zoom in to include only lines and curves with a blue sky acting as background.

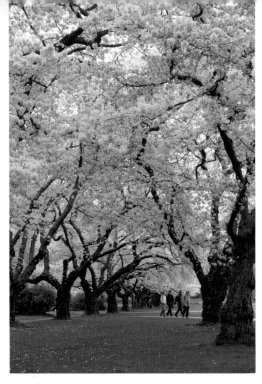

Cherry trees in bloom on "The Quad" at the University of Washington

Inside the Pacific Science Center is the **Tropical Butterfly Exhibit (2)**, a good place to visit at any time of year. Here's one place where I wouldn't bring a tripod. It's often crowded, and I don't want kids tripping over my tripod and either dumping my equipment or, worse, hurting themselves. Plus tripods are impractical. Butterflies move, and by the time you get your tripod legs adjusted, the butterflies will have moved again. A monopod is a good option, but one of the best ways to photograph butterflies is by using flash with a lens capable of focusing close.

Pro Tip: Photographing Butterflies
Several good options for getting close-ups are:

A macro lens. A 200mm macro would be best because of the working distance it gives you. A 100mm macro lens will also work; you just need to get closer to the butterfly.

A telephoto zoom lens with diopters. Diopters—sometimes called close-up filters—attached to a zoom lens in the 70mm to 300mm range work wonderfully.

A telephoto lens with an extension tube (and maybe a teleconverter). A 300mm lens with a 25mm or 50mm extension tube will give you working distance as well as enough magnification to make excellent butterfly photos.

To use flash on insects, you need to use a flash bracket to get the flash out over the lens. I've had the best success by getting the flash out over the end of the lens and pointing it to about where the subject will eventually be. With the flash close to the subject, the light becomes more diffuse because the flash head is large relative to the subject, making it a large light source. Because the flash is so close, you may need to use your smallest aperture openings or risk overexposure. I suggest testing out your setup before using it in a real photo situation.

Directions: From I-5 take the Mercer Street exit and follow signs to Seattle Center. Parking is plentiful.

Glazer's Camera (3)
While not a photographic destination in itself, if you're near the Seattle Center you might as well make your way over to the biggest, best-stocked camera store in Seattle. Even if you don't really need anything, it's always fun to visit the toy store and tease yourself. Don't blame me, though, if you can't leave without spending some money.

Directions: From Seattle Center, take Mercer Street east to Eighth Avenue. Turn right, and drive a block south to Republican. It's a bright-red building that's hard to miss. From I-5, take the Mercer Street exit, and make a left at the first light onto Fairview Avenue. Take the next right onto Republican Street. Glazer's will be five blocks up on your left.

University of Washington Campus: Cherry Trees in Spring (4)

Another iconic Seattle scene is the blossoming cherry trees at the University of Washington. Every year in late March and early April, 30 Japanese cherry trees explode into full bloom on "the Quad"—the university's Liberal Arts Quadrangle. The trees create a wonderful counterpoint to the Collegiate Gothic buildings that surround the Quad, making this location a favorite of Seattle photographers. I'd suggest you bring a full array of lenses from wide angle to telephoto. You may even want your macro gear for close-ups of the blossoms.

On overcast days, concentrate on the area below the trees' canopy. In other words, don't include the sky.

If you're there on a sunny day, be sure to include the classic buildings as well as the brilliant blue sky. You'll have more trouble photographing under the tree canopy due to the greatly increased contrast, but whether cloudy skies or clear, you'll get great shots.

During the week parking can be a problem. I suggest parking at the University of Washington Book Store on 15th Avenue between 45th and 43rd streets, and browse for books or visit the café before or after your shoot. I also suggest downloading campus maps at www.washington.edu.

Directions: From I-5 take the 45th Street exit, and head east. Turn right on 15th Avenue. The University Book Store will be on your right. Cross 15th Avenue to the campus, and walk in a general southeast direction.

Washington Park Arboretum (5) and Seattle Japanese Garden (6)

I don't think you could exhaust all the photo opportunities in the Washington Park Arbore-

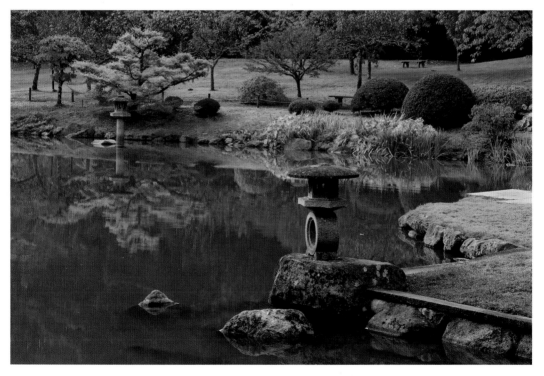

Seattle Japanese Garden

tum. This is a nature photographer's playground. And if you're into photographing people, you'll find plenty of them here, as well: The park is very popular.

Though there are photo opportunities throughout the year, the arboretum is at its most beautiful in spring and fall. In May, the rhododendrons and azaleas are in full bloom, and in October, the myriad maples provide spectacular color.

The park is big, so stop by at the visitors center to pick up a map. Your best bet is to park at the visitors center, and cross Arboretum Drive to Azalea Way, a three-quarter-mile "promenade" that will lead you through the rest of the park.

The Woodland Garden is less than a quarter mile along Azalea Way and features Japanese maples and a couple of ponds—an ideal fall-foliage destination. Rhododendron Glen is actually easier to reach via Arboretum Drive. It's about a half mile from the visitors center and has some limited parking. Rhododendrons typically bloom in early May, and you'll find blossoms in a variety of colors.

The beautiful, very photogenic Seattle Japanese Garden is located inside the Washington Park Arboretum. Note that tripods are not allowed during normal visiting hours. Several days a year, however, in April, May, and October, the garden opens early to admit a limited number of photographers (usually about 10), and tripods are allowed for these sessions. Reservations are required, and there is an additional fee ($25 as of this writing). Call 206-684-4725 for information and registration. If you're serious about photographing here, I highly recommend paying the $25. It's worth it.

The gardens are open Tuesday through Sunday at 10 AM from March through November, Monday through Sunday from May through August. Admission is $5.

Directions: From I-5, take exit 168 (Bellevue-Kirkland) to SR 520. Take the first exit to Lake Washington Boulevard E. Go straight at the light onto Lake Washington Boulevard, following the signs to the arboretum. When you get to the stop sign at Foster Island Road, turn left to the arboretum. For the Japanese Garden, instead of turning left on Foster Island Road to go toward the arboretum's visitors center, turn right, and continue on Lake Washington Boulevard for about 0.8 mile.

Kerry Park (7)

This small sidewalk park on Highland Street on Queen Anne Hill offers the quintessential Seattle view: the Space Needle and Seattle Center, downtown buildings, Mount Rainier, and Elliot Bay. What a vista! If you have only a short time in Seattle, put this location on your must-see list.

Depending on the time of year, this location is good for both sunrise and sunset, not to mention the postcard-type images to be made toward the middle of the day. In summer, however, Mount Rainier can easily be lost in the haze of midday.

This is a great spot to come for sunset, but be sure to stick around for twilight when the buildings begin to light up, with the colorful Space Needle in the fore. This will be best in the fall and winter and on weekdays, when sunset happens while people are still in their offices. I'll let you deal with the traffic as you try to leave (I suggest grabbing some dinner and waiting for rush hour to end.)

Directions: From I-5, take the Mercer Street exit (exit 167). Make the first right onto Fairview and then left in one block onto Valley Street. Valley Street will turn into Broad Street. Follow Broad to Denny Way, and turn right. At First Avenue N turn right again for six blocks to Roy. Turn left on Roy and then right on Queen Anne Avenue. Go up the hill five blocks,

and turn left on W Highland Drive. The park will be two blocks down on your left.

Seattle Waterfront (8)

The Seattle waterfront should appeal to the travel photographer. From the ferry dock, wander north. You'll pass Ivar's seafood restaurant (great fish 'n' chips), Ye Old Curiosity Shoppe, and the Seattle Aquarium. North of the aquarium is the Odyssey Maritime Discovery Center. From the rooftop observation deck you can use a wide-angle lens to take in a panorama of the city and the waterfront. A telephoto lens lets you grab the details.

From the waterfront, you can explore much of the city on foot, including **Pioneer Square** (see #11) and the **Pike Place Market** (#9). Another way to get around is to hop on the free waterfront street car. Not only is this good transportation, but it's a photo subject in itself.

Directions: From I-5 take the Safeco Field exit (164B), and turn right at Fourth Avenue. Take the next right on to Royal Brougham Way. Go past the stadiums and beneath the viaduct (the elevated highway), and turn right on Alaskan Way. Drive north several blocks to the waterfront area.

Pike Place Market (9) and Steinbrueck Park (10)

Another iconic Seattle tourist destination, Pike Place Market is a treasure trove for travel and lifestyle photographers. Here you'll find salmon-tossing fish vendors, colorful fruit and vegetable displays, Rachel the Pig (a brass sculpture), the original Starbucks, and a whole lot more. The main entrance to the Market, at Pike Place and Pike Street, is where you'll find Rachel as well as the Pike Place Fish Company, known worldwide for quality fresh seafood as well as soaring salmon. Just hang out for a few minutes, and you'll be treated to the unique site of salmon-flinging fishmongers.

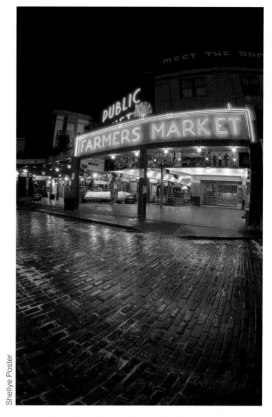

Pike Place Market early in the morning

Because the market is crowded, tripods are discouraged. In fact, you'll probably be asked to remove your tripod if you set it up. But if you're there early enough before the crowds arrive, you may be able to get in a few shots on the tripod. A monopod is another option.

For great views of Elliot Bay, the Olympic Mountains, and the Seattle skyline, wander a couple of blocks north on Pike Place to where it intersects with Western Avenue and Virginia Street. **Steinbrueck Park** will be on your left. The park is a great place for views of ferries crossing Puget Sound. Looking south from this viewpoint is the Alaskan Way Viaduct, the ferry terminal, piers with container ships and cranes, the sports stadiums, and, in the background, Mount Rainier.

Directions: From the waterfront area, walk north to the Market Hillclimb stairs. Take the stairs to the top. Parking is available near the Hillclimb. Parking is also available in Market Garage at 1531 Western Avenue, just down the hill from Victor Steinbrueck Park.

Pioneer Square (11)

About nine blocks south of Pike Place Market is the Pioneer Square district, which encompasses several city blocks. Here you'll find Pioneer Square itself, which is actually triangular in shape—a cobblestone area bordered by Yesler Way and First Avenue. Galleries, a totem pole, a statue of Chief Seattle, and an iron-and-glass pergola are some of the photographic attractions you'll find. You'll also likely find street musicians and other "residents" occupying the benches. If you're into character studies, I'm sure you'll find plenty of subjects.

Besides photography, there are plenty of other things to see and do in this area. Pioneer Square is where you'll find the **Seattle Underground Tour**, which is really worth taking if you've got the time. Visit www.underground tour.com for more information.

On First Avenue and Main Street is the historic **Elliot Bay Bookstore**. While it's not really a photo opportunity, it's a great place to lose yourself for a few hours.

If you're really interested in exploring this area, visit the Pioneer Square Web site at www .pioneersquare.org.

Directions: I think the easiest way to get to Pioneer Square is to first get to the waterfront area (see **Seattle Waterfront, #8**), find parking, and walk. There are also metered street parking and parking garages throughout the city.

Washington State Ferries (12)

Some of the best views of the city are from the water, and taking a ferry ride is one of the best and easiest ways to go. Ferries to Bainbridge Island and Bremerton leave the Coleman Dock regularly throughout the day. If you're exploring the waterfront area and you have the time, walk on board, and take a ride across the sound. Full schedules can be found at www .wsdot.wa.gov/ferries.

You won't want to use a tripod on the ferry because vibrations will be transmitted right into your camera. If you're photographing the city from the water, you won't need a lot of depth of field, so just use a wide-open aperture, and get the fastest shutter speed you can. If you want to include part of the ferry in your picture, then you'll need some depth of field. Lenses that utilize vibration-reduction technology can be a real plus on ferries.

Ferries will pass each other somewhere part way across the sound, which will give you a good chance to get shots of ferries on the water. Mount Rainier is to the south, and on a clear day there's a good chance of getting pictures of a ferry with Mount Rainier in the background. Since both you and your subject will be moving, try to get your shutter speed up around 1/125th to 1/250th of a second or faster.

Myrtle Edwards Park (13)

Located at the north end of Seattle's Waterfront, Myrtle Edwards Park gives great views across the sound to the Olympic Mountains as well as south toward Mount Rainier. A lot of bicyclists, joggers, and walkers use this park, giving photographers ample opportunities for people shots. From several vantage points, you can line up shots that have the container ship cranes and Mount Rainier as a background. Using a long lens (300mm or more), compose a shot with the path in the foreground and Mount Rainier looming large in the background, and just wait for someone to ride, run, or stroll into your frame.

Directions: From the Waterfront area simply walk north to where Alaskan Way makes a 90-

degree turn to the east. The trail to Myrtle Edwards Park begins here.

Olympic Sculpture Park (14)

Still under construction as of this writing, the 8.5 acre Olympic Sculpture Park promises to be a worthy addition to downtown Seattle and a good place to photograph. Planned features include sculptures, native flowers, quaking aspen, and astounding views of the Olympic Mountains, Elliot Bay, and downtown Seattle.

Directions: The park is near Myrtle Edwards Park between Elliot Avenue and Western Avenue.

Opening Day of Boating Season (15)

Seattle, being a maritime city, takes its boating seriously. One of the major events of the year is opening day of boating season. Festivities include the Dragon Boat Exhibition Race, the prestigious Windemere Cup Regatta crew races, and a parade of boats. All of this can be seen from alongside the **Montlake Cut**, the narrow canal running east and west connecting Lake Union to Lake Washington. The best place to set up is right along the Cut. A walkway leads beneath the Montlake Bridge on both sides of the canal, and you can pretty much just pick where you want to stand.

The crew races, which feature teams from all over the world, are fun to photograph. It's especially challenging to capture facial expressions of the rowers. Keep your lens trained on the competitors as the races end; you'll be rewarded with looks of joy, exhaustion, and disappointment, depending on the respective outcomes. Longer lenses in the 200mm to 400mm range work well for this. There are also great opportunities for candid people shots; I'd recommend bringing at least a midrange telephoto in the 80mm to 200mm range for these. Longer lenses also work well. You'll also want wider lenses to photograph the overall scenes that include crowd shots and groups of boats.

For information and program schedules, visit www.seattleyachtclub.org/OpeningDay.

Directions: Plan on getting here early. I've found that the easiest place to park is at the Museum of History and Industry, which is adjacent to the Montlake Cut. From I-5 take exit 168B (SR 520), get in the far right lane, and get off at the first exit. At the light, go straight across Montlake Place to E Lake Washington Boulevard, and take the first left (24th Avenue E) to the Museum of History and Industry. From there just make your way north a short distance to the Montlake Cut. Parking is also available at the many University of Washington parking lots on the north side of Montlake Bridge.

Woodland Park Zoo (16)

The Woodland Park Zoo is a wonderful place to practice your wildlife photography and get some pretty good pictures along the way. As with most wildlife work, long lenses will serve you best.

Many of the exhibits house the animals in as close to their natural environment as possible, making natural-looking photographs a lot more possible as well. The zoo grounds are divided into different zones representing dif-

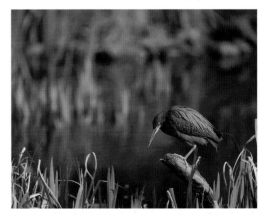

Heron at Woodland Park Zoo

ferent world climates, so you'll be photographing in rain-forest environments as well as far-northern climates.

During the summer months, the zoo features an exhibit of northwest native butterflies. See page 18 for tips on photographing butterflies.

If you're visiting in the summer, be sure to take a look at the **Woodland Park Rose Garden** adjacent to the parking lot at the 50th Street entrance.

Directions: From I-5, get off at 50th Street (exit 169), and head west on 50th for 1.3 miles to the South Gate at N 50th and Freemont Avenue N. The zoo is open every day of the year at 9:30 AM (it's kind of fun to come here on Christmas). Admission is $10.50 for adults, parking is $4. The butterfly exhibit runs from May through September, and admission is $1. For more information, visit www.zoo.org.

Volunteer Park (17)

Volunteer Park contains both the Volunteer Park Conservatory and the Asian Arts Museum.

The conservatory houses remarkable displays of orchids, bromeliads, ferns, cacti, and more. The lighting in the conservatory is perfect for close-up photography, but space is limited, so you probably won't want to bring your whole camera bag; a close-up lens will probably do. Tripods are allowed Monday through Friday only, and you must be prepared to move out of the way for other visitors. If you're a commercial photographer or doing for-profit photography, you need to get a permit from the Parks Scheduling Office: 206-484-4080. Hours: 10 AM to 4 PM daily; 10 AM to 7 PM Memorial Day through Labor Day. Admission is free.

The view from the Asian Arts Museum looks west to the Olympic Mountains, with a view of the Space Needle. In front of the museum is a donut-shaped sculpture titled *Black Sun*. By placing yourself in the right spot, you can put the Space Needle right in the opening of the sculpture.

Directions: Volunteer Park is near the Capitol Hill area of the city. From I-5 heading north, get off at E Olive Way (exit 166). Bear right on E Olive Way, which merges into E John Street. You'll come to a T at 15th Avenue E. Turn left; the park entrance is 0.75 mile on your left. From I-5 southbound, take the Bolston Avenue/Roanoke Street exit (168A), and turn left onto E Roanoke Street. Turn right at 10th Avenue E and then left onto E Boston Street. E Boston becomes 15th Avenue E. The park entrance is on your left approximately 0.5 mile from 10th Avenue E.

Gasworks Park (18)

This popular park on the north shore of Lake Union is packed full of photographic opportunities year-round. From the great view of the city to the colorful machinery of the old gas plant, you'll find plenty to keep you busy.

From the shore of Lake Union you can take in a panorama of the city or wait for a float plane to take off or land. Since you'll be facing south, the best time of day to photograph will be either morning or late afternoon. Wander the paved pathways to the top of the kite-flying hill, and you'll find a sculptured sundial, which makes for a good foreground for scenes looking out over the rest of the park.

A covered area full of brightly painted machinery makes Gasworks Park a good photo destination no matter the weather. This area is open on four sides with windows in the roof, so you'll need to exercise caution (photographic caution, that is) when photographing here, especially if it's bright outside. Wide-angle lenses to midrange telephoto zooms work well here.

Directions: From I-5, take the 45th Street exit, and go west. Turn left on Meridian Avenue N.

Machinery at Gasworks Park

Meridian ends at Gasworks Park. Turn right on N Northlake Way to the parking lot.

Magnolia Park (19)

From this 12-acre park you'll have views of the city, West Seattle, Elliot Bay, Mount Rainier, and the Olympic Mountains. Use the plentiful madrona trees as foreground and framing elements. There are also several large maple trees and in the fall, their orange leaves litter the ground. Try using one of the benches as an anchoring element in a wider view of Puget Sound and the mountains.

Magnolia Viewpoints (20): From Magnolia Park, continue north on Magnolia Boulevard one block, turn left on Howe Street, and then left again to continue on Magnolia Boulevard. Continue following Magnolia. This section of the road has several stunning views. Near Monte Vista Place is a parking area. Since it faces west, Magnolia Park and the viewpoints will work best as sunset locations.

Directions: Make your way to Elliot Avenue W, which you'll eventually intersect if you head downhill west of the Seattle Center. Follow Elliot Avenue W to the Magnolia Bridge. Cross the bridge (you'll be on W Garfield Street), and head uphill. W Garfield turns into W Galer and then into Magnolia Boulevard W. The park will be on your left, and you'll find parking at 31st Avenue W.

Discovery Park (21)

Discovery Park, the largest park in Seattle, is a good place for just about any nature subject. Here you'll also find a lighthouse, and if you're into photographing Native American cultural events, there is the annual **Seafair Indian Days Powwow** held at the Daybreak Star Indian Cultural Center.

This is a park where you'll need to devote some time since most of the access is by trail. The main loop trail through the park is 2.8 miles and leads to several habitats including meadows, forests, and sand dunes. There are plenty of side trails, as well.

The **West Point Lighthouse** is accessible by trail, shuttle bus, or car, but you'll need a permit to drive the road. Photographers wanting to photograph the lighthouse may obtain a permit by calling the Seattle Parks Department at 206-684-4080.

For more information, seasonal brochures are available online at www.seattle.gov/parks/Environment/discovparkindex.htm. For information about the Pow Wow events, visit www.unitedindians.com/powwow.html.

Directions: From Seattle Center, take Broad Street west, down the hill, and turn right on Elliot Avenue (from anywhere near Seattle Center if you make your way to the west you'll eventually come to Elliot Avenue). Follow Elliot Avenue northward; it eventually turns into 15th Avenue W. At W Dravus Street, turn right on 20th Avenue W. Twentieth becomes

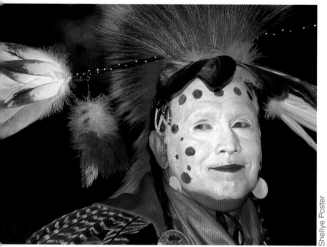

Powwow at Discovery Park

Shellye Poster

Directions: From I-5, get off at Mercer Street (exit 167), turn right at the bottom of the ramp onto Fairview, and then left at the next light onto Valley. The Center for Wooden Boats is on the right, just past Daniel's Broiler. Admission is free.

Fisherman's Terminal (23)

One of the best places in the city to photograph a working harbor, Fisherman's Terminal, home of the northern Pacific fishing fleet, is ideal for reflections, piles of nets, and boat details. This is a great place to photograph on either a clear or a foggy morning. On clear days you'll have reflections to play with and on foggy days you'll get shots with an ethereal quality to them. Lenses in the 80mm to 300 mm range work best to isolate reflections. You can try a polarizer for different effects on the reflections. Use wide-angle lenses if you want to include foregrounds such as boats or nets.

Directions: From I-5, take the Mercer Street exit. At the bottom of the off ramp turn right on Fairview Avenue N. Take the next left onto Valley Street, and then turn right on Westlake Avenue N. Westlake will become Nickerson Street. Follow Nickerson for 1.5 miles and then veer left to W Emerson Street, crossing the bridge over 15th Avenue. Emerson Street becomes W Emerson Place. Turn right onto 19th Avenue W, then right on Nickerson Street, and left on 18th Avenue W.

Hiram Chittenden Locks (24) and Carl S. English Botanical Garden (25)

Locally known as the **Ballard Locks**, this is another Seattle must-see site.

Walking in, you'll immediately come to the Carl S. English Botanical Garden, where you'll find more than 500 species and 1,500 varieties of plants. Wandering around the grounds, landscape and close-up photographers will find plenty of subjects here. Spring and summer are

Gilman Ave W, and Gilman then becomes W Government Way. Follow W Government Way to the east entrance of the park.

Center for Wooden Boats (22)

Though I'm no sailor, I really enjoy and appreciate the craftsmanship and beauty of a wooden boat. There's just something about the graceful lines and curves along with the colors and textures that appeal to me, so this "hands-on maritime museum" is especially enjoyable. Early morning is the best time to photograph here for a couple of reasons. First, the light is best in the morning. Second, it's quieter and you'll most likely have the place to yourself.

Before you even go down to the dock, wander around the grounds—where you'll find chains and gears and propellers, as well as boats in various states of restoration.

But for me, the main attractions are the wooden boats moored along the dock. Try using a telephoto zoom in the 80–200mm range to isolate portions of the boats or their reflections in the water. If the water is calm, you can get a mirror-perfect image. If the water is choppy, look for colorful abstracts.

best for the flowers. Stop by the visitors center for a map of the garden.

The main attraction here, though, is the locks. The locks permit marine travel between Puget Sound and Lake Washington, raising or lowering boats to the proper level, depending on which direction they're going. It's quite a sight.

The best spots to set up are just "downstream" of where the boats are heading; you should find plenty of space for viewing. Use a wide-angle lens to take it all in, but be aware of the sky. If it's a typical Seattle day, you'll likely have bright clouds to deal with. Here's where graduated neutral-density filters save the day.

On the south side of the locks, you'll find more to photograph. Cross to the other side where you'll see the *Salmon Waves,* a collection of wave-shaped, curling metal sculptures. You can make a straightforward shot of these, or get a little more creative, lining up the curls for abstract graphic images.

Right next to the waves sculptures are the stairs leading to the fish-ladder viewing area. If you wait long enough, you'll always see fish, but you can maximize your chances by visiting between August and October, when the salmon runs are at their peak. Light levels are low, so you may need to increase the ISO setting on your digital camera. Try some slower shutter speeds, capturing the movement of the migrating salmon.

Directions: From I-5, take the Mercer Street exit. Turn right at the light onto Fairview Avenue. Take the next left on to Valley Street. In three blocks take a right onto Westlake Avenue N. Westlake will turn into Nickerson Street. In about 1.5 miles turn north (right) on to 15th Avenue W. Cross the Ballard Bridge, and turn left at the first light onto North Market Street. Follow Market Street through town, and bear left at the Taco Time onto NW 54th Street. Then take an immediate left after the Lockspot Café.

Boeing Museum of Flight (26)

When I was a little boy, I used to love building plastic model airplanes. I'd spend hours piecing them together, making sure of every detail. The Museum of Flight is model heaven for any little boy (or big boy, for that matter). Here, planes line the floors and hang from the ceiling—except these planes are the real things.

The museum consists of three main indoor exhibits and two outdoor exhibits. The Great Gallery contains the main display. Here you'll find gliders from the early days of flight, fighter planes from every major war, even the giant Lockheed Blackbird spy plane. The Personal Courage Wing displays 28 rare World War I and World War II fighter planes in upper and lower galleries. The Red Barn (Boeing's original plant) tells the story of the birth of aviation and contains a recreated factory workshop with table saws and other woodworking tools, along with wooden fuselages in various stages of construction.

If you're visiting during the day, be aware of the bright windows; the building is practically

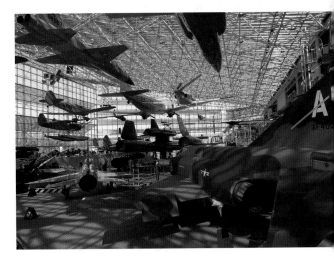

Boeing Museum of Flight

all glass. The lighting is surprisingly good, though, and if you're careful, you shouldn't have too many problems with burned-out highlights. Photographing at night solves the window problem completely.

Wide-angle, normal, and midrange telephoto lenses work well here. Tripods are allowed throughout most of the museum, the exceptions being the airplanes at the Airpark. I'd highly recommend bringing along your tripod, especially if you're visiting at night.

Outside the main building you'll find various fighter planes. Some of these are behind fences, but others aren't, and you can get pretty close to them.

Across E Marginal Way and about a block north is the Airpark. Several airplanes are on display, including the Concorde; the *Spirit of Everett,* which was the first 747 off the assembly line; and the Boeing VC-137B *Air Force One.*

You can board the Concorde and *Air Force One,* but tripods are not allowed.

Directions: From I-5, take exit 158, and head west. Turn right on E Marginal Way. The museum is 0.25 mile on the right with plenty of free parking.

The Museum of Flight is open seven days a week from 10 AM to 5 PM. The Airpark is open 11 AM to 3:30 PM. Admission is $14 for adults. For special events and closure information, check the museum's Web site: www.museum offlight.org.

Kubota Gardens (27)

A must-visit location for landscape and nature photographers, Kubota Gardens combines Japanese gardening and native northwest plants in a 20-acre park. You'll find ponds, streams, and waterfalls among hills, valleys, and rock gardens. Two traditional Japanese bridges accent the landscape, the more photogenic of them being Moon Bridge.

Though the gardens are beautiful at any time of the year, the best times to photograph are in the spring and fall. In April and May the azaleas and rhododendrons are in bloom. In October the maples are at peak color.

Directions: Traveling north on I-5, take exit 157 (Martin Luther King Jr. Way), and stay on Martin Luther King Jr. Way. Turn right on Ryan Way, left on 51st Avenue S, right on Renton Avenue S and then right on 55th Avenue S.

Moon Bridge, Kubota Gardens

Traveling south on I-5, take exit 158 (Pacific Highway S/E Marginal Way). Turn left toward Martin Luther King Jr. Way, and follow the directions above. Download a map at www .kubota.org

Rizal Viewpoint (28)

The view from the **Jose P. Rizal Bridge** is one of the very best views of the city that you'll find. The view is looking north toward the city, your foreground an S-curve of freeway leading the viewer right into the picture. This is a classic spot to set up for a night shot of the city. Long exposures will cause headlights and taillights to streak into white-and-red curves, with the lights of the city adding an extra splash of color.

A wide-angle lens works best here if you're after the freeway-into-city shot. Take care to choose a spot where you can avoid getting the bridge railing in your shot. You can also get some nice telephoto shots of the city from here, especially at sunset or sunrise.

Directions: From I-5 northbound, take the James Street exit (164A), and turn right on James, which becomes Cherry Street. Turn right onto 12th Avenue, and follow 12th as it crosses over I-90. This bridge is the Jose P. Rizal Bridge. Turn right at the light, and continue on 12th. Look for parking on the street, or just continue up the hill to Jose P. Rizal Park, and park there. From I-5 southbound, take the James Street exit (165A), and turn left on James Street at the second light. Follow the directions as above.

West Seattle: Harbor Avenue (29)

Probably the best overall view of the city can be found on Harbor Avenue SW in West Seattle. From here you can take in a spectacular view of the city from across Elliot Bay. Starting just north of Salty's restaurant, the view gets better and better, with the best view being from Don Armeni Park. This location

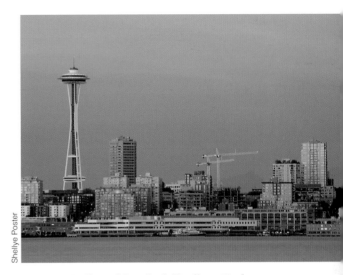

Space Needle and Seattle skyline from Harbor Avenue in West Seattle

just screams panorama, so think about taking several shots and stitching them together in Photoshop. If you do this, I suggest a telephoto lens in the 80mm to 200mm range.

At sunset the warm light falling on the skyscrapers reflects in Elliot Bay, and at twilight the lights of the city will do the same, making this one of the very best sunset locations in the city.

Directions: From I-5, go west on the West Seattle Freeway (exit 163), and then take the Harbor Avenue SW exit. Drive north on Harbor Avenue SW. Harbor Avenue will turn into Alki Avenue SW in about 1.8 miles.

West Seattle: Belvedere Viewpoint (30)

Take in the view of Elliot Bay and the Seattle skyline from this viewpoint. Here you'll have more of an aerial view, which makes it easier to isolate the ferries from the background of the city.

Directions: From the West Seattle Freeway traveling west, take the Admiral Way exit, and follow Admiral Way up the hill. The viewpoint is at the top of the hill at Olga Street.

Madrona trees in Lincoln Park, West Seattle

West Seattle: Lincoln Park (31)

With great views across the sound to the Olympics, views of the ferries, and some great trees, 135-acre Lincoln Park has plenty to keep a photographer busy. Noted nature photographer Art Wolfe lives in West Seattle and has photographed here many times, so you know it has to be good.

Trails crisscross throughout the park, and there's plenty to explore. From the north parking lot, two trails lead into the park. My favorite area to photograph in the park is where the madrona trees grow on a bluff at the south end. From the north parking lot, take the trail located at the south end of the lot. Follow the trail, always heading west. Eventually you'll come to a wide trail that follows the top of the bluff. Turn left. The trail will begin to descend, and you'll be able to see the ferry dock through the trees. This section of trail has some great madronas. The light here is especially nice in the late afternoon. Look for openings in the trail with views of the water and Vashon Island. These will be good places to photograph the ferry boats at sunset.

Directions: From I-5, take the West Seattle exit to the West Seattle Freeway. At the end of the freeway, follow the signs to Fauntleroy Way SW. Stay on Fauntleroy Way SW until you come to the park (approximately 2.5 miles)

Federal Way

Located south of Seattle on the grounds of the Weyerhaeuser Company headquarters, the **Rhododendron Species Garden (32)** and **Pacific Rim Bonsai Collection (33)** are two of Washington's premier botanical displays.

If you're a nature photographer living in the South Seattle/North Tacoma/Auburn area, you'd be nuts not to buy a membership to the Rhododendron Species Botanical Garden. More than 500 species of rhododendron (the Washington state flower is the coast rhododendron, *Rhododendron macrophyllum*) are planted here, and it's simply one of the best places you could go to practice the craft of nature photography. This garden, surrounded by towering Douglas fir trees, has just about everything you need: close-up subjects, landscape opportunities, colors, shapes, great subjects, and easy access.

The best time to visit is March through May, with the peak blooms in late April to mid-May. Try for an overcast day, as well, and give yourself plenty of time; there is a lot to photograph.

The Rhododendron Garden is open March through May 10 AM to 4 PM, Friday through Wednesday. June through February the garden is open 11 AM to 4 PM, Saturday through Wednesday. Admission is $3.50. For information on membership, visit www.rhodygarden.org, or call 253-838-4646.

The Pacific Rim Bonsai Collection shares

the same main entrance as the Rhododendron Species Garden, though here admission is free. This outdoor museum of living art features 60 bonsai from six different Pacific Rim nations. Each piece is displayed on its own stand with a yellowish concrete background, much like an art gallery, which this truly is. These trees are genuine works of art, and the settings really make each one stand out.

You are welcome to photograph here for personal or nonprofessional use. Keep in mind that each display is literally a piece of art and is therefore protected by copyright laws. Permission is required to photograph for any commercial use. For more information or for usage permission, contact curator David De Groot at 253-924-5206.

From March 1 to September 30, the collection is open from 10 AM to 4 PM Friday through Wednesday. From October 1 to February 28 the hours are 11 AM to 4 PM Saturday through Wednesday.

The **Weyerhaeuser Company Headquarters—Lupine Fields (34)** offer a stunning display of color in June. You can photograph the hybrid lupines right from the side of the road if you wish, or follow the trails on the south side of the road to the nearby pond that fronts the headquarters building. The lupine fields are on both the north and south side of 336th Street. This is a great place to either pull out your macro lens and get intimate with flowers or use a midrange telephoto like an 80–200mm zoom lens to photograph colorful patterns. Either way you'll have plenty of subjects on which to train your lens.

Directions: From I-5, take the 320th Street exit (exit 143) in Federal Way. Turn east, and then turn right at Weyerhaeuser Way. At the traffic circle turn right on to 336th Street. For the lupine fields you can park anywhere along the road—the shoulder is very wide. To get to the gardens, make the next left-hand turn onto Weyerhaeuser Road, following signs to the rhododendron garden. After about 0.3 mile, a large parking lot will be on your left (before you get to the garden entrance). Park here, and take the short trail to the entrance.

Mukilteo Lighthouse (35)

Not only do you get to photograph a pretty lighthouse, you can photograph ferries, as well. The lighthouse is adjacent to the ferry terminal in Mukilteo, and you can get some nice photographs of the lighthouse with ferries either docked or coming and going on their way to the Clinton terminal on Whidbey Island.

This is a popular place for weddings and so may be closed to the general public at times—though often you only need to wait awhile. This is also a popular place for sightseers and other photographers, so I suggest getting here early. Since the lighthouse faces north, in the summer it gets good light for either sunrise or sunset. There are flowers in front of the lighthouse as well as along the walk leading to it. You'll be rather close, so a wide-angle lens works best here. A fence surrounds the lighthouse grounds, but the gate to the left is usually unlocked.

Directions: From I-5, take exit 189 to SR 526, the Boeing Freeway. Follow the freeway for about 4.5 miles to an intersection with the Mukilteo Speedway. Turn right, and follow SR 525 to the ferry terminal. Turn left on Front Street to the lighthouse.

The East Side

Just east of Seattle, reached by crossing either the I-90 or the SR 520 floating bridges, is the city of Bellevue. Though this area is getting very crowded with condos, high-rises, and wider freeways (plus the accompanying traffic), there are some wonderful places to photograph.

Bellevue Botanical Gardens (36)

Several distinct "environments," including the Yao Japanese Garden, the Alpine Rock Garden, and the Native Discovery Garden, put the Bellevue Botanical Gardens near the top of my list of "nature in the city" locations and make it one of my favorite gardens to visit. You'll find small waterfalls, ponds, cultivated flowers, woodlands, native northwest plants, rock gardens, and more.

The best time to photograph here is in the spring and summer for the flowers and in October for the Japanese Garden.

The garden is open daily from dawn until dusk. From just after Thanksgiving until the end of the year, the garden is open until 9:30 PM for Garden d'Lights, the annual holiday light display.

*Downtown Bellevue building details
from Bellevue City Park*

Directions: From I-405, take the NE Eighth Street exit, and turn right on 120th Avenue. Drive south along a curvy road for 3.4 miles to the first light, and turn left onto Main Street. Drive up the hill. The gardens are about three blocks on your right.

Bellevue Downtown Park (37)

Flanked by a shopping mall and condominiums and with high-rise buildings for a background, Bellevue Downtown Park is an oasis of calm in the heart of one of western Washington's fastest growing cities.

The park is nearly encircled by a half-mile horseshoe-shaped pathway bordered by a stepped canal on one side and trees on the other. Bridges cross the canal to a 10-acre lawn. At the southwest end of the park, the canal lets out to a wide pool and then a 240-foot-wide waterfall that empties into a reflecting pool below. The northeast side of the park is dotted with sculptures.

You can use a wide-angle lens for landscape shots that include the walkway and/or the canal as a foreground curve, with the tall city buildings in the background.

The waterfall is fun to photograph, too. Try for long shutter speed to blur the motion.

Using a telephoto lens, you can pick out geometric shapes from the glass-sided high-rise buildings. Try using a polarizer here, turning it to achieve different effects.

This site is especially nice early or late in the day with the warm light of sunrise or sunset reflecting from the tall buildings. This also makes a good spot for night photographs of the city.

Directions: Coming from Seattle, take I-90 east to the Bellevue Way exit. You'll be heading north. Turn left on NE Second Street and then right into the south parking lot, or continue and turn right on 100th Avenue NE to the west parking lot.

II. North Sound

Whidbey Island

SPRING ★ ★ ★ **SUMMER** ★ ★ ★
FALL ★ ★ **WINTER** ★

Whidbey Island is a combination of farmlands, charming towns, and spectacular scenery. There's a lot to photograph here, from beautiful gardens to the impressive Deception Pass Bridge to inviting forests.

Whidbey Island is accessed either from SR 20 via Deception Pass in the north, the Port Townsend/Keystone Ferry on the west side, or the Mukilteo/Clinton ferry on the south side. If you're in the Seattle area, the quickest way is the Mukilteo/Clinton ferry.

Fort Casey State Park (38)

In the early 1900s, Fort Casey, along with Fort Worden across the water in Port Townsend and Fort Flagler on Marrowstone Island, guarded the entrance to Puget Sound. As with all the old forts along coastline, you'll find some great architectural photography possibilities along with the great views.

Because it faces west, the **Admiralty Head Lighthouse** may be best photographed in the late afternoon. For a postcard-type shot, try a nice blue-sky day. The best view is on the south side of the lighthouse, making the north sky your background. You can get pretty close to the lighthouse, so a wide-angle lens works well.

Another possibility looking west is a telephoto shot (400mm to 600mm) of Port Townsend with the Olympic Mountains directly behind. Be aware that wind and atmospheric haze can have a huge negative effect on photographs of this nature. A sturdy tripod, fast shutter speeds, and polarizing filters can help here.

From the lighthouse area you'll see the gun batteries. You can either walk to them, or get back in your car and drive. The photographic lure of these batteries is found in the lines and curves, the texture and the shadows. Think simplicity, and start picking out pieces. If you want to go inside the batteries, be sure to bring along a flashlight.

Directions: Take the Port Townsend Ferry to Keystone. Turn left off the ferry, drive 0.4 mile, and turn left into the park.

Coupeville Waterfront (39) and Ebey's Landing (40)

If you enjoy travel photography and tourist towns, take a walk around the historic **Coupeville waterfront**. You'll find shops, a museum, and the Coupeville Harbor Store, all located on the Coupeville Wharf, which juts out into Penn Cove.

When you've had your fill of the waterfront, head out to Ebey's Landing. This mixture of farmland, high bluffs, and rocky beaches is a

Fort Casey State Park

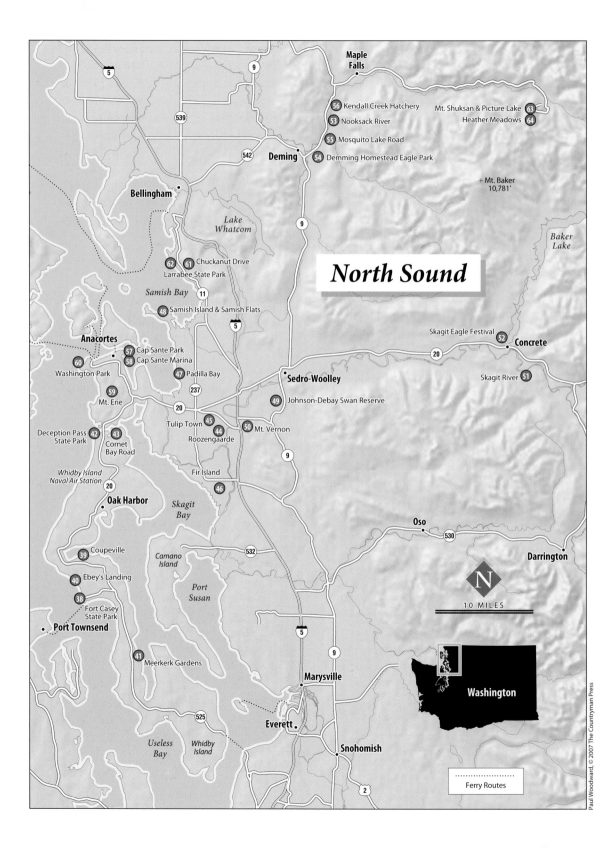

Maple Falls

9

56 Kendall Creek Hatchery

Mt. Shuksan & Picture Lake 63

53 Nooksack River

Heather Meadows 64

55 Mosquito Lake Road

539

542 Deming

54 Demming Homestead Eagle Park

+ Mt. Baker
10,781'

Bellingham

Lake
Whatcom

9

Baker
Lake

62 61 Chuckanut Drive

Larrabee State Park

Samish Bay

11

48 Samish Island & Samish Flats

5

Skagit Eagle Festival 52 Concrete

Anacortes

20

57 Cap Sante Park

58 Cap Sante Marina

Skagit River 51

60

47 Padilla Bay

Washington Park

Sedro-Woolley

237

49 Johnson-Debay Swan Reserve

59 Mt. Erie

20

Tulip Town 45

42 Deception Pass State Park

20

44

50 Mt. Vernon

43 Cornet Bay Road

Roozengaarde

9

Whidby Island
Naval Air Station

20

Fir Island

46

Oak Harbor

Skagit
Bay

Oso

530

Darrington

North Sound

39 Coupeville

Camano
Island

532

40 Ebey's Landing

Port
Susan

N

38

Fort Casey
State Park

10 MILES

Port Townsend

41 Meerkerk Gardens

5

9

Washington

Marysville

525

Everett

Snohomish

2

Useless
Bay

Whidby
Island

Ferry Routes

5

Paul Woodward, © 2007 The Countryman Press

great place to spend a late afternoon and sunset. In this area are several barns worthy of a stop. Continue on Hill Road as it begins to wind down to beach level and **Ebey's Landing**. You'll see several openings from which to photograph the curve of the beach and the high bluffs above. The road is narrow with very little shoulder space, so you'll need to drive farther down the hill to find parking. Using a wide-angle to normal lens, you can capture an image of the beach, the bluff, and the farmland at the top. There's even a barn you can include. Since the cliffs here face west, this is a better late afternoon to sunset location.

Directions: From the Keystone ferry, follow SR 20 into Coupeville, turn right on Main Street, and continue to the waterfront. To reach Ebey's Landing, follow Main Street south, crossing SR 20. Main turns into Engle Road. About 1.5 miles from SR 20, turn right on Hill Road.

Meerkerk Gardens (41)

One of those tucked-away Pacific Northwest gems, Meerkerk Gardens is a premier rhododendron garden, with trails, benches, lots of great flowers, and more. It's not a big place (10 acres of gardens surrounded by 43 acres of native woodland), so my suggestion is to just enjoy a stroll through the garden before getting out your gear.

The best time to visit is in mid-May, when the rhododendrons are at their peak. However, deciduous trees will add another dimension of color in the fall. Some wonderful design work has been put into this garden so be sure to explore the multihued patterns in the plant groupings. Visit on an overcast or rainy day if you can, and be sure to use a polarizer. Open daily 9 AM to 4 PM; $5 admission. There is a Port-a-Potty on site. For more information, visit www.meerkerkgardens.org.

Directions: From Clinton ferry, drive north on SR 525 for 15 miles to Resort Road. Turn right on Resort, and in about 0.5 mile turn left on Meerkerk Lane; look for the sign directing you to the parking area. From Deception Pass, drive south on SR 20, and continue straight when SR 20 intersects with SR 525. Continue south on 525. Two miles south of Greenbank turn left on Resort Road. Follow directions above. From the Keystone ferry, follow SR 20 to the intersection of SR 525. Follow the directions above.

Deception Pass State Park (42) and Cornet Bay Road (43)

Deception Pass State Park is the most popular state park in Washington—and for good reason. It's also popular with photographers, mainly due to the dramatic **Deception Pass Bridge**. Here's a place where bad weather can make a great photo. Some of the best photos I've seen of this bridge have been taken in foggy or rainy conditions.

Deception Pass State Park has several areas of photographic interest. The bridge is pretty obvious, and there are at least a couple handfuls of options for photographing it. The bridge actually is two spans. The main span is from Whidbey Island to Pass Island, and the smaller span bridges Pass Island and Fidalgo Island. Approaching from the Fidalgo Island side, a few parking spaces are available at pullouts. A large parking area is on the Whidbey Island (south) side of the bridge. Sidewalks are on either side of the bridge and stairways lead to underpasses at each end and on Pass Island.

Since the bridge itself is oriented north to south, it can get good light at both sunrise and sunset, though you can also get some pretty great misty mood shots at any time of the day if the weather cooperates. The classic shot is from a viewpoint on the Fidalgo Island side of the bridge.

Late light on Deception Pass Bridge, Deception Pass State Park

There are actually quite a few options from the bridge itself. If you take the stairs to the underpass on Pass Island you'll be confronted with the geometric construction of the bridge. A lot of possibilities can be found here for architectural photography, looking up at the details and graphics.

Shooting from the bridge area is not the only option for good bridge pictures. About a mile south of the bridge (on the Whidbey Island side), turn east on **Cornet Bay Road**. Some maps have it as "Coronet" Bay. In fact, signs in the area conflict, as well.

You'll see a couple of good viewpoints along the way, but follow this road to a parking and picnic area at its end. The road is blocked to traffic from here, but about 200 yards up the road is a side trail leading to the beach. You'll have a pretty good view of the east side of the bridge from here. The bridge is due west, making this a good sunrise spot at just about any time of the year and a good sunset spot in the spring and fall. Use a lens in the 200mm range to isolate the bridge.

On the other side of SR 20 from Coronet Bay Road is another entrance to Deception Pass State Park. Enter here and follow the signs to **North Beach**. There's a big parking lot near a restroom. A short trail behind the restroom leads to a couple of great viewpoints above the beach. From here you'll be looking up at the bridge. This is a normal to mid-telephoto lens shot. You can also get down to the beach and use a wide-angle lens with whatever foreground happens to be available (driftwood, rocks, and the like.)

Another trail from the parking lot starts near the trash receptacle and leads to the beach. I like the other viewpoint better, but since these trails are short you can take a look at both areas.

While it's tough to turn away from the bridge, you owe it to yourself to visit the rest of the park. **Rosario Beach** and **Bowman Bay** are on the Fidalgo Island side of the park. From the bridge, take Rosario Road, the first road to the left. In 0.75 mile turn left on the Rosario Beach Road, and follow it to the parking lot. This can be a fantastic sunset location. Short trails lead from a picnic area to the beach. Offshore, **Urchin Rocks** provides an anchor point for sunset shots.

Bowman Bay can be another good sunset location, though it doesn't have the same foreground possibilities as Rosario Beach.

Cranberry Lake is on the Whidbey Island side of the park and is popular with canoeists and fishermen. It also makes for a good sunrise or sunset location. The park entrance is about 1 mile south of the bridge. Follow the signs to Cranberry Lake and West Beach.

The road that leads to North Beach (above) passes through some magnificent old-growth forest. If you're here on a cloudy or foggy day, count yourself lucky and photograph the forest. Be sure to pull out the polarizer (it's not just for darkening skies).

Directions: From Seattle, drive north on I-5, and take exit 230 in Burlington to SR 20 westbound. Turn left at the bottom of the off ramp, and follow SR 20 toward Anacortes. In 12 miles turn left, following SR 20 west for 6 miles to Whidbey Island and Deception Pass State Park. From Port Townsend, take the Keystone Ferry, and follow SR 20 for 28 miles to Deception Pass.

Tulip Fields of the Skagit Valley

SPRING ★ ★ ★ ★ SUMMER ★
FALL ★ WINTER ★

Every April tourists from around the region flock to the **Skagit Valley Tulip Festival** to see, photograph, and wander along the vast tulip fields of the Skagit Valley, located about 60 miles north of Seattle. If you live in the Puget Sound area or are visiting in April, this is a wonderful, must-visit destination for every photographer.

In the past there were many more fields, but these days it's pretty much limited to two main farms, Roozengaarde and Tulip Town. Both are great to photograph, and they're different enough to make visiting each one worth it.

You can, of course, just drive around the valley, photographing from the roadside. The Tulip Festival usually runs the entire month of April. Generally, the best time to come photograph is around mid-April, though this is dependent on several factors, including the severity of the preceding winter, spring rains, and temperature.

The display garden at **Roozengaarde (44)** doesn't open until 9 AM, but you can get into the surrounding fields at any time. Because of the crowds and the limited parking I recommend arriving early. In fact, try getting here near sunrise. Since it can be muddy here, wear boots. I also recommend rain pants or knee pads for kneeling.

When I photograph here, one thing I look for is graphics. The rows of colorful tulips are an obvious choice. Think about running the rows horizontally, vertically, and diagonally through the frame.

When the display garden at Roozengaarde opens, you'll be treated to even more fun. (There is a nominal admission fee—something like $3.) Once inside, you'll find dozens of tulip varieties in very photogenic settings. Look for tulips growing in front of a rustic split-rail fence, or beneath blooming fruit trees. There's also a windmill.

Tulip Town (45) is more of the same, yet it's different. Instead of the display garden like at Roozengaarde, it's a more open area with rows of purple, red, white, yellow, and orange tulips. A horse-drawn "Tulip Trolley" is also quite photogenic. Tulip Town also charges a nominal fee.

For more information and to download a map of the fields, visit www.tulipfestival.org.

Pro Tip: Look for the odd man out, like a tulip of one color in a field of another color. Use a

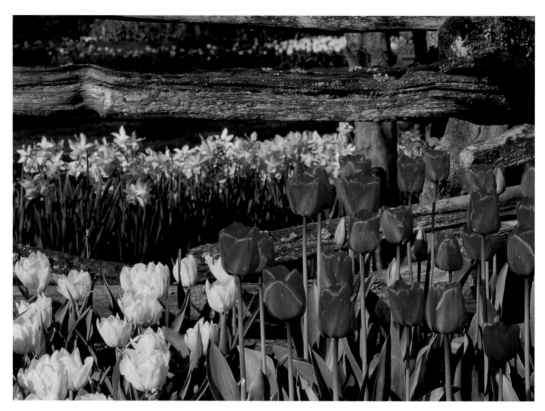

Roozengaarde Tulip Farm

long lens to isolate this, and place the odd tulip somewhere off center in the frame. This is real easy to do, and this situation is easy to find.

Directions: From Seattle, drive north on I-5, and take exit 221 at Conway. Turn left, cross the freeway, and turn right onto Fir Island Road. Small signs along the side of the road direct you to the tulip festival. Follow Fir Island Road for about 5 miles, turn left on Best Road, and cross the North Fork Skagit River. In 3 miles turn right onto Calhoun Road, and in two blocks turn left onto Beaver Marsh Road. Roozengaarde will be on your right; continue just past the entrance to a parking area on the left. Parking is free. To get to Tulip Town, travel north from Roozengaarde on Beaver Marsh Road, turn left at McLean, and make the next right onto Bradshaw. Tulip Town will be on your left.

Birds of the Skagit and Nooksack

SPRING ★★ SUMMER ★★
FALL ★★★ WINTER ★★★★

Every winter bald eagles, snow geese, trumpeter and tundra swans, and other migrating birds can be seen and photographed from a variety of locations in the Skagit Valley, Samish and Padilla Bays, and along the Skagit and Nooksack Rivers. Though birds can be found year-round, the winter months seem to offer the most to the photographer.

Fir Island (46)

One of the very best places to photograph snow geese is on Fir Island, near the tulip fields of the Skagit Valley. The birds spend the summer months in the Arctic but winter here in the Skagit, which is right along the Pacific Flyway. The best time to come is November through early February.

Follow Fir Island Road, and keep your eyes out for snow geese in the fields on either side of the road. Approximately 3.7 miles from the freeway, Fir Island Road makes a right-hand turn to the north. Keep going straight on Maupin Road. It will soon take a turn to the north. Along here you have a real good view of **Mount Baker**. Though the snow geese can be found throughout this area, and you may need to drive around a bit to find them, I've had my best luck along this stretch of the road.

On a clear day, if a flock happens to be in fields to the east of you, it's possible to get pictures of the birds with Mount Baker in the background. If you set up here with a 400mm or 500mm lens you can frame up Mount Baker, and just wait. Sooner or later the birds will flock, filling the air and filling the frame. Chances are you'll get several good pictures of Mount Baker fronted with a frame full of flocking snow geese.

One caution here: When the snow geese start flocking and flying overhead, beware of . . . well, you get the picture. An umbrella might come in handy.

I've also enjoyed tracking individual or small groups of birds as they come in for landings. This takes a little practice, but there are a lot of birds here, so you should become adept in no time.

Also investigate **Mann Road**. Just as you cross the South Fork Skagit River on Fir Island Road, turn right onto Mann Road. The fields along here can contain snow geese and tundra and trumpeter swans. Look for raptors in the trees. Follow Mann Road until it intersects with Wylie Road. Turn left. Wylie becomes Game Farm Road and leads the Skagit Wildlife Area. This area, along with any other sites managed by the Department of Fish and Wildlife, requires a Recreational Use Permit. These are available at many sporting goods stores or online at: fishhunt.dfw.wa.gov/wdfw/vup.html

Directions: From Seattle, drive north on I-5, and take exit 221 at Conway. Turn left, cross the freeway, and turn right onto Fir Island Road. You'll cross over the South Fork Skagit River. Fir Island sits between the arms of the North and South Fork Skagit Rivers.

Padilla Bay and Samish Island

Some of the birds you'll see in this area include dunlins, swans, snow geese, raptors, great blue herons, and more. Often the best strategy is to simply drive around and keep your eyes open. I prefer to photograph right from the car, using a window mount or a bean bag to support my lens. Your car makes an excellent—and portable—blind. I'll drive along with the camera in the passenger seat, ready at a moment's notice.

Padilla Bay Reserve (47)

The entire area between SR 20 to the south, SR 11 to the east, and Padilla Bay to the west is good for bird viewing and photography. You can drive around this general area looking for birds; your car makes an excellent blind. Even though the traffic here is very light, try to get off the road as much as possible. Use a window mount or a bean bag to stabilize your big lenses.

Directions: Take Interstate 5 north from Seattle to exit 230 (SR 20). Take SR 20 west for about 6 miles. Turn right (north) on Bay View–Edison Road, and drive about 3.6 miles to **Bay View State Park**. The **Breazeale Interpretive Center** is just past the state park entrance on

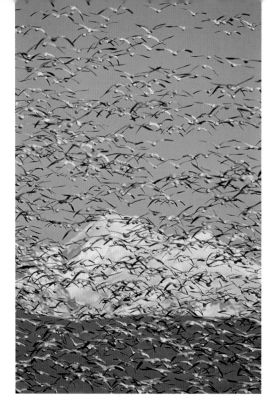

Snow geese in flight from Fir Island

the right. Stop here to pick up maps. These maps will show the fields in the area where each species is most likely to be found.

Samish Island and the Samish Flats (48)

The area of Samish Island and the Samish Flats is considered to be one of the best birding locations in the northwest part of the state. Look for falcons, eagles, short-eared owls, and shorebirds in the fields along Samish Island Road.

After stopping in at the **Breazeale Interpretive Center** (see #53), head north on Bay View–Edison Road, and turn left on Samish Island Road. Drive slowly, and keep your eyes open. Soon you'll come to a parking lot and an area known as "The West 90." This is an area managed by the Washington Department of Fish and Wildlife and is one of the best places in the state to see short-eared owls. You'll need a Recreational Use Permit (see info in #52, Fir

Island) to park here. This is one of those places that warrant multiple visits as chances are slim that you'll get great owl shots on the first visit.

This should get you started. After investigating the Samish Island area, just keep driving the back roads to see what else may be found.

Johnson–DeBay Swan Reserve (49)

Tucked away in Mount Vernon near the Skagit River, this 331-acre reserve is an excellent place from which to photograph trumpeter swans and tundra swans.

Approximately 3,000 swans winter here, fed by corn grown specifically for the birds. You'll also see bald eagles and other raptors, snow geese, several species of ducks, and Canada geese.

The area is fenced so that the birds can remain as undisturbed as possible. The swans may or may not be close, so you might only be able to get a distant view. But even if the swans are too far away to photograph, don't despair. Keep you eyes trained overhead. Every so often a group of swans will fly by. Be ready for this by having your tripod positioned so that it's easy for you to swing the lens to the sky.

Directions: Northbound on I-5 from Seattle, take exit 227 to SR 538. Turn right (east) on SR 538 (College Way) for 1.2 miles, and then turn left (north) on N Laventure Road. N Laventure turns into Francis Road. Approximately 5 miles after turning onto Laventure, turn left onto Debay Island Road. This left turn is on a large right bend in the road and can be easy to miss. The gate is usually open by 8 AM (and stays open until dusk). If it's not, simply park in the outer lot.

Mount Vernon (50)

I've also had some luck spotting swans in the fields of the Mount Vernon/Burlington area. Drive SR 20 just east of I-5, and look for swans in the nearby fields. Side roads run adjacent to

most of these fields, so you're usually able to get at least within good viewing distance.

Skagit River (51)

Every winter hundreds of bald eagles spend the winter near the Skagit and Nooksack Rivers. This is the largest concentration of wintering eagles (300 to 500) in Washington State. Viewing and photographic conditions depend on several factors, including water levels and food supply. The eagles depend on the carcasses of spawned salmon that get washed up on the riverbanks and gravel bars. In good years the water levels in the rivers are low enough for there to be plenty places for this to happen, and many of these places are easy for humans to get to. If the water levels are too high, the food source is spread out and diluted—and so are the eagles.

SR 20 from Concrete east to Marblemount is probably the best bald eagle viewing. In the town of Rockport, stop at the **Howard Miller Steelhead Park**. East of Rockport good viewing sites are at mileposts 99 and 100. On the weekends, look for the Eagle Watcher Volunteers at pullouts along the highway. These folks can offer suggestions as to where the best concentration of eagles may be found.

Pro Tip: Though you can get good photographs with telephoto lenses in the 200mm to 300mm range, this is really big-glass territory. That means 500mm and 600mm lenses and teleconverters.

Skagit Eagle Festival (52)

The Upper Skagit Bald Eagle Festival in Concrete is held the last weekend in January or the first weekend in February, though eagle viewing is probably best from December through January. The Skagit River Bald Eagle Interpretive Center in Rockport is open from early December to mid-February Fridays, Saturdays, and Sundays from 10 AM to 4 PM. Be sure to stop by and ask where the best eagle sightings have been. More information, directions, and maps are available at www.skagiteagle.org.

Directions: From I-5, take exit 230 (SR 20). Drive east approximately 30 miles to Concrete. Rockport is another 8 miles, and Marblemount is 8 miles beyond that.

Nooksack River (53) and Deming Homestead Eagle Park (54)

This area, where the Mount Baker Highway follows the Nooksack River, is one of the lesser known nature hot spots, and one of the very best places to view eagles in the lower 48.

Directions: From Interstate 5 take exit 255, and turn east onto SR 542, the Mount Baker Highway. Follow SR 542 past the town of Deming (16.5 miles) to the intersection with SR 9. Stay on SR 542. About 0.5 mile past the intersection, turn right onto Truck Road. After a short distance look for the Deming Homestead Eagle Park on your right; this is often a good spot for eagles. Trails lead out to the river from here.

If you continue on Truck Road, you'll see a small dirt road to the right at approximately 0.9 mile from where you left the highway. This road will dead end very quickly. Park and walk

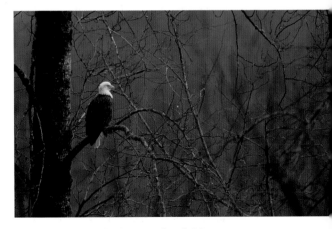

Bald eagle along Nooksack River

from here, following a trail right to the river. Eagles are often seen here on the gravel bars or perched in the trees.

Mosquito Lake Road (55)

You can continue on Truck Road another 1.3 miles to Mosquito Lake Road. (Mosquito Lake Road is 2.3 miles from the intersection of SR 9 and SR 542). Across the street is a fire station. This is a good place to park. From here, walk to the bridge a hundred yards or so to the east. If there are eagles here, you can shoot right from the bridge, or cross the bridge and make your way down to the river on the north side of the bridge.

From here, get back in your car to check out some other spots. Drive Mosquito Lake Road across the bridge, and take the first left onto **North Fork Road.** Drive this road for about

Fishing nets at Cap Sante Marina

a mile or so, looking to your left for eagles perched in trees. There are two good viewing sites with limited parking.

Go back to Mosquito Lake Road, and continue another 4 miles to a high bridge crossing the **Middle Fork Nooksack.** This area sometimes has a large concentration of eagles. If the spirit moves you, continue along Mosquito Lake Road, looking for more eagles.

Kendall Creek Hatchery (56)

Go east on Mount Baker Highway (SR 542) from Mosquito Lake Road. In about 4 miles, turn right onto Hatchery Road to the Kendall Creek Hatchery. Park and walk past the buildings and continue left to the river in search of eagles.

Anacortes Area

SPRING ★ ★ ★ SUMMER ★ ★ ★
FALL ★ ★ ★ WINTER ★

Anacortes is about 80 miles north of Seattle. This town of 15,000 has a thriving arts community, several parks, and a pleasant small-town atmosphere. The Anacortes Art Festival, one of the largest art fairs in western Washington, is held every August.

Anacortes is also home to two oil refineries, which, when photographed in twilight, make for interesting and colorful subjects.

Directions: From I-5, follow SR 20 west to Anacortes. Once in town, SR 20 coincides with Commercial Avenue until it turns on 12th Street, ending at the ferry dock.

Cap Sante Park (57)

The views from Cap Sante Park include Mount Baker, Padilla Bay, the oil refineries, San Juan Islands, and the Cap Sante Marina. This is an excellent place to photograph both at sunrise and sunset. If I lived in Anacortes, I'd be a

regular visitor to this spot at different times of year, in different weather, and different lighting conditions.

At night, the lights of the refineries create an eerie glow. Mount Baker is visible to the northeast, which is a good reason to photograph here at sunrise.

Just below you to the west is the Cap Sante Marina. In the distance are the San Juan Islands. At sunset, use the marina as foreground, with the sun dropping behind the San Juans. You may need a graduated neutral-density filter to capture all the detail.

Directions: Follow Commercial Avenue through town to Fourth Street. Turn right (east) onto Fourth Street to an intersection with V Avenue, and turn right. You'll see a sign to Cap Sante. Follow the short road to its end.

Cap Sante Marina (58)

Wander around the marina looking for interesting colors, reflections, and other things nautical. Piles of nets are often pretty easy to find in this area.

Directions: From Commercial Avenue, turn west on 14th Street, then right on Q Avenue, and then left on Seafarer's Way.

Mount Erie (59)

For the best views on Fidalgo Island, drive to the top of Mount Erie. There you'll find trails that lead to viewpoints. You'll be able to see Mount Rainier, Mount Baker, the Olympics, and Puget Sound. There's a nice view of the refinery with Mount Baker behind.

The northeast view looks toward Mount Baker, with Padilla Bay and the refineries below. This would be a good place to shoot at twilight or at night. It's also not a bad sunrise spot.

The south viewpoint has the best unimpeded view. The walkway is right next to the communications towers. Below is Lake Camp-

bell, with Mount Rainier in the distance. This is a good location for either sunrise or sunset.

A quarter mile down from the top there's another viewpoint worth stopping at, with views to the southwest.

Directions: Follow SR 20 (Commercial Avenue) into Anacortes. At the first light (32nd Avenue), turn left and then left again onto H Avenue. In 2 miles, turn left onto Mount Erie Road. Note that Mount Erie Road is open from 5 AM to 10 PM. The road is short, but it's steep and has some sharp curves, not really suitable for RVs or trailers.

Washington Park (60)

Anacortes's Washington Park is a popular spot for picnickers, sightseers, birdwatchers, and photographers. A 2.3-mile one-way scenic loop road takes you around the park to several good viewpoints. The loop road is open daily from 10 AM to dusk for drivers and 6 AM to 10 AM for foot traffic.

There are plenty of views of the San Juan Islands and Olympic Mountains. One of the most popular photo subjects is a Douglas fir tree that juts out nearly horizontal from shore. You'll find it near the second pullout on the loop road. To me, the tree stands out the best if you're on its east side facing northwest.

At 1.8 miles on the loop road, you'll come to **Channel View**, which looks across to Burrows Island. A wonderfully gnarly juniper tree grows right next to the parking area. It makes a good subject on its own, or use it as foreground or framing material for wider views.

The park is also a good place for bird photography year-round.

Directions: Follow the SR 20 signs toward the ferry dock, but keep on Oakes Avenue instead of turning on to Ferry Terminal Road. Follow Oakes to Washington Park. It's a one-way loop road.

Far-North Sound

SPRING ★★★ SUMMER ★★★
FALL ★★★ WINTER ★

In the farthest northern reaches of Puget Sound you'll find the town of Bellingham, one of Washington's most scenic drives, our oldest state park, and access to some spectacular mountain scenery.

Chuckanut Drive (61)

One of the most scenic drives in the state, Chuckanut Drive (SR 11) offers some stunning views west over Samish Bay toward the San Juan Islands. The best views are from pullouts 0.5 mile north of mile marker 12 and 0.5 mile north of mile marker 11. Telephoto lenses will work best to cut out any trees that would otherwise get in the way of your composition.

Directions: From I-5 at Bellingham, take exit 250 to SR 11 (Old Fairhaven Parkway). Stay on SR 11 as it turns into Chuckanut Drive. From I-5 at Burlington, take exit 231 to SR 11 (Chuckanut Drive).

Larrabee State Park (62)

Larrabee State Park is actually Washington's first official state park. Its west-facing shoreline features rocky coves and old weathered trees. Boulders along the rugged shoreline are made up of sandstone eroded and striated much like the sandstone of Utah's national parks. You also may find large chunks of driftwood with much the same patterning. Combinations like this make great juxtapositions.

From the parking lot, follow the trail to the left of the amphitheater. The trail passes under the railroad tracks and comes to a T; keep to the left, and follow the trail a short distance to the shore. From here you can either photograph from above or pick your way down to the shoreline boulders, depending on the tide.

Watch your footing here as rocks and driftwood may be slippery.

This is a great sunset location. Use the boulders along with any big hunks of driftwood as foreground elements for wide-angle compositions. You'll likely need a low tide, or at least not a high tide, to use the boulders as close foreground subjects. Otherwise you can shoot from the bluff area above the high-tide mark. Spring, winter, or fall would probably produce the best illumination for the boulders.

Larrabee State Park also has some pretty good camping—a good place from which to base yourself if you want to take some time to explore more of the park.

Directions: From I-5 at Bellingham, take exit 250 to SR 11 (Old Fairhaven Parkway). Keep on SR 11 as it turns into Chuckanut Drive. It's about 6 miles from the freeway exit to the park entrance. From I-5 at Burlington, take exit 231 to SR 11 (Chuckanut Drive). Drive 14 miles to the park entrance.

Mount Shuksan and Picture Lake (63)

One of the most recognizable sites in Washington, Mount Shuksan and Picture Lake, is also one of the easiest places to get to—though it will take you a few hours to get there.

It's really hard to beat this location, especially for fall color in late September to mid-October. Pick a day when the sun's going to be out and the sky is going to be blue. If you're lucky, you'll get a few puffy white clouds, too.

Park at Picture Lake, and follow the short trail to the shore. There's a boardwalk as well as a large viewing area from which good shots can be made.

When the air is still, it's possible to get a perfect mirror image of Mount Shuksan in Picture Lake. Toss in fall foliage along the far shore of the lake, and you have a classic mountain scene worthy of framing. Wide-angle to normal lenses work well here. You can also use

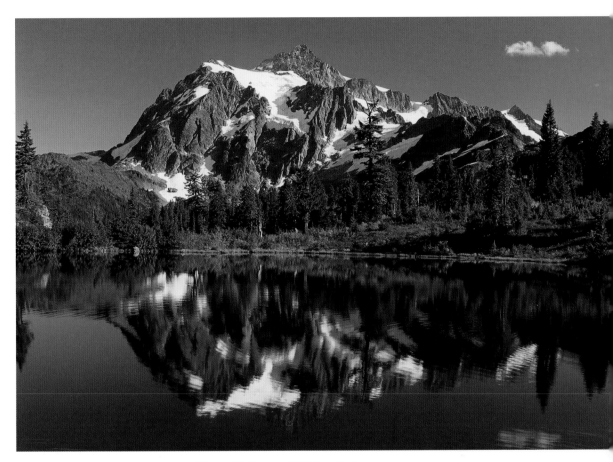

Mount Shuksan and Picture Lake

a short telephoto to frame up a shot with fall foliage at the bottom of the frame and Mount Shuksan taking up the rest of the picture.

If you're here for this fall color shot, the best time of day is right around 4 PM.

You could spend an entire day in this area. Get here early, and instead of stopping at Picture Lake, continue to the end of the road at **Heather Meadows (64)**. Several trails lead to viewpoints, and you can see both Mount Shuksan and Mount Baker. Look for small tarns that will reflect the peaks and/or fall color. Ultrawide lenses work wonders in places like this. The **Heather Meadows** area is probably best early to midmorning. Then go eat lunch, relax a bit, and head to Picture Lake. Makes for a picture-perfect day.

If you're after some winter shots, Mount Baker just happens to be one of the snowiest places on the planet. It's a popular ski area and the roads are kept plowed and open during the winter, weather permitting. You'll probably need snowshoes or cross-country skis to get around.

Directions: Simply get on the Mount Baker Highway (SR 542, exit 255) in Bellingham, and point yourself east. In about 53 miles you come to Picture Lake. Parking is on the left side of the road.

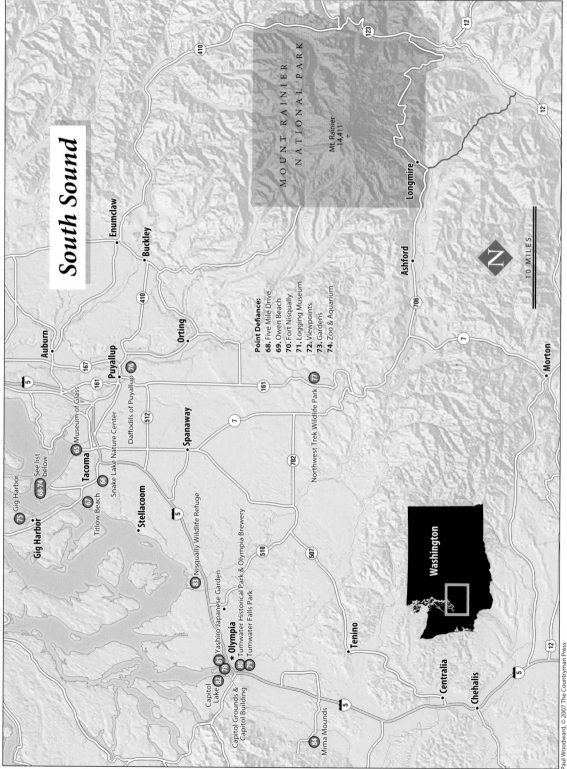

South Sound

MOUNT RAINIER NATIONAL PARK

Mt. Rainier
14,411'

Point Defiance:
68. Five Mile Drive
69. Owen Beach
70. Fort Nisqually
71. Logging Museum
72. Viewpoints
73. Gardens
74. Zoo & Aquarium

N
10 MILES

Enumclaw
Buckley
Longmire
Ashford
Morton
Auburn
Puyallup
Orting
Spanaway
Stellacoom
Tacoma
Gig Harbor
Olympia
Tenino
Centralia
Chehalis

Museum of Glass
See list below
68-74
75
67
66
65
70
77
161
161
512
410
410
167
5
5
5
5
5
7
7
123
12
12
12
706
702
510
507

Snake Lake Nature Center
Titlow Beach
Daffodils of Puyallup
Nisqually Wildlife Refuge
83
Yashiro Japanese Garden
Tumwater Historical Park & Olympia Brewery
Tumwater Falls Park
80
81
78
79
Capitol Lake
82
Capitol Grounds & Capitol Building
Mima Mounds
84
Northwest Trek Wildlife Park

Washington

Paul Woodward, © 2007 The Countryman Press

III. South Sound

The south Puget Sound area includes Tacoma south to just beyond Olympia. Though most of the tourist sites are in the greater Seattle area, plenty of photographic opportunities can be found in the south Sound. Since I enjoy training my lens on shapes and forms, I particularly like the Museum of Glass in Tacoma. I don't think you could exhaust the possibilities in several lifetimes of photography.

Tacoma Area

SPRING ★★★★ SUMMER ★★★
FALL ★★★ WINTER ★

Tacoma, called "The City of Destiny," is about 30 miles south of Seattle on I-5 and is Washington's third largest city. Also in this general area is the picturesque town of Gig Harbor, a fantastic wildlife park, daffodil fields, and more.

Museum of Glass (65)

The Museum of Glass is known for its collection of blown glass by the famed artist Dale Chihuly. Other artists are featured here, as well, and all the work is truly stunning. Photographed from inside or outside, the museum offers the photographer plenty of colors, shapes, and graphics.

Photography in the museum display area is prohibited, but it's allowed in the Museum Store, the Educational Studios, and the Hot Shop. The Hot Shop features live glassmaking whenever the museum is open (except for breaks and lunch). Tripods are allowed in these areas; however, I'd discourage using a tripod in the Museum Store because there is very little room and lots of fragile glass.

Though photography is not allowed in the museum display areas, there is plenty of glass art to see and photograph in the **Chihuly Bridge of Glass**, a 500-foot pedestrian overpass connecting the museum to the Washington State History Museum and downtown Tacoma.

As you walk across the bridge, you'll pass through two major display areas, the **Venetian Wall** and the **Seaform Pavilion**. Each has wonderful displays but the Seaform Pavilion features a ceiling containing some 2,300 pieces by the artist. Point your camera straight up and fill the frame with shapes and colors. During the day the glass is backlit by natural light and at night artificial lighting is used.

The outside of the museum is also interesting. The main feature is the tilted metallic cone that houses the Hot Shop. A wide spiral staircase leads to the museum's roof and access to the Bridge of Glass. On top you'll find Buster Simpson's *Incidence*, a 120-foot-long series of glass panes in a reflecting pool. The triangular

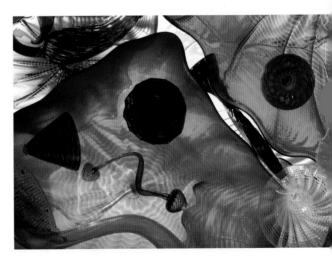

*Glass art in Chihuly Bridge of Glass,
Museum of Glass*

arrangement is perfect for photographers who appreciate graphic images. Like most landscape photography, this is best photographed early in the morning or late in the afternoon, even into twilight.

You can also photograph the entire museum from across the Foss waterway. From the museum, drive south on Dock Street to Third Street, and turn left. Turn left again onto D Street, and follow for about 0.25 mile to Johnny's Dock restaurant. An option here is to photograph the museum at night, with the interior lights providing illumination. This can only really be done in the winter when it gets dark before the museum closes at 5 PM. For more information, see www.museumofglass.org.

Directions: From I-5 take exit 133 (City Center) to I-705, and get off at the Schuster Parkway Exit. This will actually take you past the museum, but it's one of the easier ways to get there. Turn right at the first light onto S Fourth Street, which will become Dock Street. The museum will be on your left in about a mile. Parking is available in the museum's underground garage. There is also street parking if you arrive for sunrise or sunset, and the museum is closed.

Snake Lake Nature Center (66)

Snake Lake is a great place to find wood ducks in the spring. If you're lucky, you'll also see a turtle or two sunning on a log. I suggest getting here early, when wildlife is most active. A trail from the visitors center follows the lakeshore and leads to a pair of bridge crossings. The bridges are the easiest places from which to see and photograph waterfowl, along with the turtles. I recommend a relatively long lens, at least 300mm. Be prepared to shoot as soon as you get on the bridge, and make sure your gear is all set up. Have your lens attached to your camera, the camera attached to the tripod and turned on, and all the controls set to your lik-

ing. So as not to scare any of the wildlife away, approach the bridge slowly and quietly. You might get lucky with some initial shots, but don't be surprised if the birds swim away. That's OK. Just hang out for awhile, and they'll probably come back.

Directions: From I-5, exit at SR 16 (Bremerton). Take the Union Street exit, and turn right (north) onto Union Street. In about 0.5 mile turn left onto 19th Street. Follow 19th for 0.6 mile, turn left onto Tyler Street, and then an immediate left into the Nature Center.

Titlow Beach (67)

You can get a great view of the Tacoma Narrows Bridge from Titlow Beach. (By the time you read this, construction on the second bridge will be either completed or nearly so.)

Directions: From SR 16, take the Jackson Avenue exit, and turn south. Turn left (west) at Sixth Avenue. In about 0.6 mile, look for a parking area to the right. Pull in and park. Follow the old road, and cross over the railroad tracks. To the left is the Titlow Home Owner's Association. Just past this is a trail to the right leading to the beach. From here, the bridge is just to the north. To the left of the bridge, the tops of the Olympic Mountains are just visible. Any time of year and just about any time of day is good for photographing the bridge, although late afternoon to sunset is best for lighting. The bridge will be front lit from this side, and you'll be facing north.

Point Defiance

The 702-acre Point Defiance is Tacoma's premier park. It offers old-growth forest, saltwater beaches, and some great views. There are also some wonderful gardens, a logging museum, a zoo, an aquarium and more.

Five Mile Drive (68) This pleasant one-way road takes you through some nice forest

area, past Fort Nisqually, and Camp 6 Logging Museum. Park at any pullout and investigate any of the many trails that crisscross the park. Forest photography is always best on overcast or rainy days. Be sure to have a polarizer.

From the main entrance of the park, follow the signs to Five Mile Drive. Take note of the speed limit: 14 MPH. Don't ask me. . . .

Owen Beach (69) is one of the first turnoffs you'll come to along Five Mile Drive. Looking southeast, the view is of a marina and the Tacoma waterfront industrial area. To the north is Vashon Island. When the tide is out, walk to the edge of the water for a good view of Mount Rainier looming above the trees. Since the park opens at sunrise, this would be my first stop. The shot looking south toward Rainier looks great if you include people walking the beach. A polarizer is almost a must here to help cut the haze in the southern sky.

Owen Beach is also a good place to photograph ferries traveling between Tacoma and Vashon Island.

Fort Nisqually (70) was established in 1833 as the first European trading post on Puget Sound and was originally located on the Nisqually River near the present-day town of Dupont. In the 1930s the fort was rebuilt and restored at Port Defiance. Two of the original buildings remain. Today Fort Nisqually is a history museum with a working blacksmith shop, trade store, and more. Volunteers and staff wear period clothing, making this entire site very photogenic. Throughout the year events such as historical re-enactments are staged.

Open Wednesday through Sunday 11 AM to 4 PM except June through early September, when it's open daily from 11 to 5. Web site: www.fortnisqually.org.

If you enjoy photographing shapes and colors, **Camp 6 Logging Museum (71)** will be right up your alley. Gears, wheels, pulleys, and chains, many of them covered with rust, are but

Machinery details, Camp 6 Logging Museum

a few of the interesting things you'll find here. Mid-telephoto lenses like an 80–200mm zoom work great here for isolating details. This is a good location in any kind of light. On overcast days the light is soft and even, ideal for detail work. On sunny days shadows cast graphic shapes.

Point Defiance Viewpoints (72) Several good viewpoints can be found along **Five Mile Drive**. About halfway through the drive, at the end of the point, is the **Gig Harbor Viewpoint** with a view of Gig Harbor and the Olympic Mountains. One of the best Narrows Bridge views is just past mile marker 3. A short trail on the left side of the parking lot leads to a great view. Be cautious here; you'll be near a cliff. A little way past this viewpoint is the "official" bridge view. You can see more of the bridge

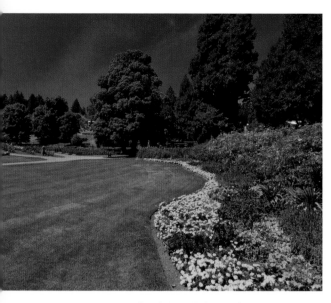

Gardens at Point Defiance

Flattery; and the **Arctic Tundra**, based on a coastal setting near Point Hope, Alaska. Some of the animals you'll see include reindeer, polar bear, Arctic fox, tufted puffin, walrus, Beluga whale, and sea otter.

Follow signs to the zoo parking lot. The zoo is open daily at 9:30 AM and closes at different times throughout the year. Admission is $10. For more information on the zoo, visit www.pdza.org.

Directions: From I-5, take exit 132 to SR16. In about 3.5 miles take the Sixth Avenue Exit, and turn left. Take the next right onto Pearl Street and follow Pearl to the park's entrance. The park is open daily from sunrise to approximately a half hour after sunset.

Gig Harbor (75)

A classic northwest shot with a marina in the foreground and Mount Rainier in the background, seen on many a postcard, can be made from the picturesque little town of Gig Harbor located across the Narrows Bridge from Tacoma.

Using a short telephoto lens like an 80–200mm zoom, this location is best shot at sunrise or near sunset. It can even make a great twilight shot. Travel photographers will enjoy wandering the town photographing shop fronts, sculptures, and tourists.

Directions: Take SR 16 from Tacoma across the Tacoma Narrows Bridge. Take the second Gig Harbor exit, and turn right on Pioneer Way. At the bottom of the hill turn left, and follow Harborview Drive around the harbor. Harborview will turn into North Harborview. Just keep following North Harborview until you come to the **Ruth M. Bogue Viewing Platform**, conveniently placed at the best location for photography. It's right next to a Cruise Holidays office. There is plenty of parking on the street if you're there for sunrise.

from here, but there are more things like trees and branches in the way.

Five Mile Drive is closed to vehicles every Saturday until 1 PM for runners, walkers, and bicyclists.

Point Defiance Gardens (73) If you enjoy photographing flowers and gardens, you'll go nuts here. There are rose gardens, a rhododendron garden, a Japanese garden, and more—all providing endless opportunities for a photographer. You can use virtually every lens you have, from wide angle to macro to telephoto.

You'll find something here nearly year-round. In spring come to photograph the rhododendrons; in summer, the roses and other summer bloomers; and in the fall come for the color of the Japanese garden.

The garden area is the first thing you'll see upon entering the park; it will be on your left. Parking is plentiful and free.

The **Point Defiance Zoo and Aquarium (74)** is a small zoo with some pretty nice displays. Exhibits include the **Rocky Shores**, which replicates the rugged coastline of Cape

Daffodils of Puyallup (76)

There used to be several places in the Puyallup/ Orting area where you could see fields of daffodils backed by Mount Rainier. Alas, apartments and condominiums have sprung up where flowers once bloomed. But there is still at least one place where you can get that quintessential shot. The **Van Lierop Bulb Farm** in Puyallup is perfectly situated for the photographer. I'm sure they planned it that way. The daffodils typically start showing themselves in late March and peak by mid-April.

If you arrive before the gates open, just drive down 134th Avenue, adjacent to the daffodil field. Along this road is the best place to photograph the fields of yellow daffodils with Mount Rainier towering in the background. Find parking well off the road. This is farming land, and very often one of those big pieces of farm equipment will migrate down this road.

The Van Lierop Bulb Farm isn't just acres of daffodils; it's also a garden. This beautiful garden—full of colorful tulips, daffodils, blossoming fruit trees, pathways, and a pagoda—is a wonderful place to spend a morning. The best time of year for the garden is mid-April through mid-May, and the staff has always been photographer friendly, so there should be no problems setting up a tripod.

The gardens are really best on an overcast day, but the fields with Mount Rainier are best on a clear morning. This means that no matter the conditions, you should be able to get some good images. I suggest early morning or late afternoon for the field and mountain shot. Midday will make for the least interesting light, but it will make a good postcard image.

Van Lierop's isn't open year-round, but then again the daffodil fields are only there late March to early April. Visit their Web site for hours of operation: www.vanlieropbulbfarm .com.

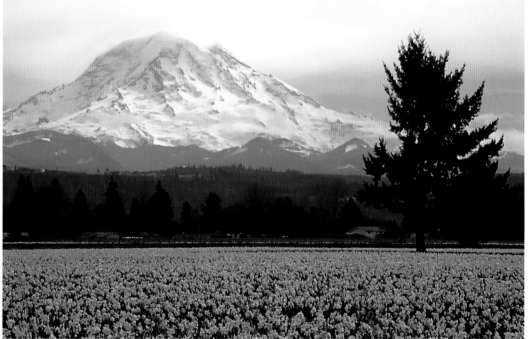

Daffodil field and Mount Rainier from Van Leirop's Bulb Farm

Directions: On I-5 coming from the north, take exit 142B (Puyallup) to SR 161 south. Follow signs into Puyallup. Turn left on Pioneer, and drive 2 miles. At 0.25 mile past Shaw Road, Pioneer takes a hard right. Turn left here, crossing the railroad tracks onto 134th Avenue E. Van Lierop's is right on the corner.

Northwest Trek Wildlife Park (77)

Not quite a zoo and not quite a game farm, Northwest Trek is a wildlife park that has a free-roaming area and an area with natural-looking enclosures. The free-roaming area is accessed by tram; the rest by plain old walking.

Tram tours will take you by free-roaming moose, deer, elk, bison, caribou, bighorn sheep, sandhill cranes, and more. The walking tour gets you close to porcupines, beavers, snowy owls, wolves, black and brown bears, and bald eagles, among others.

If you take one of the normal tram tours, photographing from the tram is difficult. But special photo tours are offered several times a year. The photo tours are limited to 15 so that it's easy to move around. The tram windows are removed, and the driver will turn off the motor when parked. Since these photo tours happen only a few times a year, you'll want to plan early for this.

From the tram, the animals can be both very close or at a bit of a distance. Long telephoto lenses in the 400mm to 500 mm range will find a use, as will a wide-angle lens. If you take the photo tour you'll have plenty of room to store and access your gear.

For the rest of the park, I'd recommend the same thing. Long lenses can be very useful for bears or for doing close-up portraits of eagles or owls. For some of the critters, like the raccoons and porcupines, you can use shorter lenses because you'll be closer (if you can get used to the smell of the porcupines).

For more information, check out the Northwest Trek website at: www.nwtrek.org. For information about the Photo Tours: www.nwtrek.org/page.php?id=135.

Olympia Area

SPRING ★★★★ SUMMER ★★★
FALL ★★★ WINTER ★★

Olympia—located approximately 60 miles south of Seattle on I-5—is Washington's state capital, and as such there are some attractive buildings, public artworks, and gardens to photograph. Just north of Olympia is one of the state's best wildlife refuges, and just south is one of nature's mysteries.

Capitol Grounds and Capitol Building (78)

State capitals are usually made to impress and that makes them great places to photograph. **Washington's capitol** at Olympia boasts fountains, sculptures, flowers, tree-lined roads, and of course, the stately building itself. From the parking along Angle Drive and SE Angle Drive you can find the **Tivoli Fountain**, the **Winged Victory** memorial, a formal garden, and more. All of these make good foregrounds or good subjects on their own. In the springtime you'll find plenty of flowers and blossoming cherry trees to serve as foregrounds or framing elements.

A great map and guide to all the memorials and pieces of art is available at www.ga.wa.gov/visitor/memorials.htm.

The main entrance to the Capitol Building is on the north side, meaning you'll be facing south. If you want to shoot from this side of the building, it's best done earlier in the morning or later in the afternoon.

A better option is the south side of the building, which has better lighting conditions as well as better foreground material. You'll find a

Washington State Capitol Building interior

flower-lined walkway and a sundial sculpture, both of which make great foregrounds for wide angle landscape shots. You'll need a pretty wide lens if you wish to use the sundial. This is also a good place to use a telephoto zoom to photograph the architectural detail of the capitol itself.

The interior of the capitol is also great fun to photograph. With its marbled interior and decorated domed ceiling, the building offers plenty to point your camera at. A wide-angle zoom lens works great here and has the advantage of being easily handheld. On the north side of the upper landing is a large bust of George Washington. Try getting slightly behind it with a wide-angle lens, and look over George's shoulder.

Because you're indoors and lighting is limited, it's a good idea to use a tripod (well, it's always a good idea to use a tripod). Tripods are allowed in the Capitol Building. If you're plan-

ning on bringing a group of photographers, though, call ahead of time to make arrangements: 360-902-8880.

Directions: From I-5 southbound, take exit 105A, and follow the signs to the capitol grounds. From I-5 northbound take exit 105, and follow the signs to the capitol grounds. From Capitol Lake (below) follow Fifth Avenue SE four blocks east of Simmons, and turn right on Capitol Way. Capitol Way takes you right to the capitol grounds. The entrances to the grounds are Angle Drive and SE Angle Drive. These one-way roads have parallel parking on either side. Parking is a reasonable 50 cents per hour. A great map and guide to all the memorials and pieces of art is available at www .ga.wa.gov/visitor/memorials.htm.

Tumwater Falls Park (79) and Tumwater Historical Park and Olympia Brewery (80)

Tumwater Falls Park features a series of cascades and a couple of good-sized waterfalls. A trail follows the Deschutes River on both sides, with bridges crossing both above and below. At the top is the mostly manmade Upper Tumwater Falls. One of the best views is on the east side of the river near a bench. In springtime the rhododendrons growing nearby will make a good foreground element. You'll want to try to keep the top of the falls out of the frame for the most part unless you like fences, poles, and wires in your photos.

On the bridge itself, by using a telephoto lens in the 80mm to 200mm or longer range, you can capture part of the falls reflected in the pool. Be sure to crop out the top of the falls to avoid any distracting elements.

Follow the short trail down either side of the river for more possibilities.

On the west side of the river you get a good view of the fish ladders at **Middle Tumwater Falls**, where you can view salmon in the fall. A photo of a leaping salmon can be a tough shot

to get, especially if you want the fish big in the frame. My suggestion is to target one spot, pre-focus, and keep your finger on the shutter button. Another option is to use a wider lens that will take in the whole scene, and just wait for the salmon to jump.

Best times: Spring and summer for green leaves in the trees, fall for some different color.

Across the Deshutes River from **Tumwater Historical Park**, the old **Olympia Brewery** can be seen.

Directions: From I-5 southbound, take exit 103, and turn left at Custer Way, which takes you over the freeway. Just on the other side of the freeway, turn right onto Boston and then left onto Deschutes Parkway. In about one block turn left onto C Street; you'll see a small sign to Tumwater Falls Park. From Tumwater Falls Park, drive north on Deshutes Way for about 0.25 mile to the entrance of Tumwater Historical Park.

Yashiro Japanese Garden (81)

This small, delightful garden is located right next to City Hall in Olympia. Visit in late April through May for blooming azaleas and rhododendrons. Visit in the fall for colorful maples. If there happens to be a snowfall in winter, the statues would make great subjects, too. You'll also find a small pond to include in your compositions.

Directions: From I-5, take exit 105 B to Plum Street/City Center. The garden will be on your right as you cross Union. The address is 1010 Plum Street SE.

Capitol Lake (82)

Follow Deschutes Parkway, and keep an eye out for great views of the Capitol Building reflected in the lake. There are lots of possibilities here but some of the best views are at the north end. There are plenty of places to park

right on Deschutes Parkway, or you could just follow Deschutes as it turns into Fifth. At Simmons, turn right into a small parking lot. Here you'll find some of the best views of the Capitol Building. In April the cherry trees lining this end of the lake are in bloom and make a great framing element.

Behind you (north of the lake) at Sixth and Water Street is **Olympia Heritage Park** and its wonderful fountain. Use a lens in the 35mm to 50mm range to capture the waters of the fountain, the lake, and the capitol. A lens in the range of 24mm to 120mm would be idea for both film and digital shooters.

The fountain operates from 10 AM to 9:30 PM on most days (closed on Mondays). Best times to visit: April through summer. Look for the red leaves of sumac along the lake in the fall.

Directions: From I-5 coming from the north, take exit 103, and turn left on Custer Way, crossing the freeway. In 0.1 mile turn right onto Boston and then right again onto Deschutes Parkway. Follow Deschutes to Capitol Lake. From I-5 coming from the south, take exit 103. This turns into Deschutes Parkway. Follow to Capitol Lake.

Nisqually National Wildlife Refuge (83)

The Nisqually National Wildlife Refuge, located just north of Olympia, is probably the best birding location in the south sound. The combination of saltwater from Puget Sound and the fresh water from the Nisqually River creates a nutrient-rich estuary that attracts birds and other wildlife in droves.

One main 5.5-mile trail loops through the refuge, and a smaller boardwalk loop trail leads past a small pond to Twin Barns and an observation platform with a good view of the wetlands and grassy fields. I suggest starting with the boardwalk loop trail; it's a good introduc-

tion to the refuge. In the spring you'll often see any number of ducks, including wood ducks, on the pond.

The 5.5-mile loop trail leads along the river, across a dike, and through different habitats. There are two photo blinds along this trail. One is located on the east side of the refuge, probably about 1.25 miles from the visitors center, just off the main trail on the short Ring Dike Trail. This blind faces south, and there's room for two, maybe three, photographers. It looks out on a marshy area, so you should see wrens, red-winged blackbirds, and more. A similar photo blind, which overlooks an open water habitat, is about 1.5 miles or so along the western side of the loop. This is a good place for waterfowl. Since wildlife is usually the most active early and late in the day, I suggest getting here as early as you can.

This is long-lens territory. For good bird photography you'll need at least a 500mm lens plus a teleconverter. For OK bird photography you can try to get away with a 300mm lens.

The refuge is open daily during daylight hours, and the gate opens at sunrise. The entrance fee is $3 per car unless you have a Golden Eagle, Golden Age, or Golden Access Pass. Best wildlife viewing is from spring to early fall.

Pro Tip: In addition to all that fine camera gear you're carrying, bring along a pair of binoculars. They'll help you find your subjects and, at the very least, you'll get to see more neat birds.

Directions: The Nisqually Refuge is 8 miles east of Olympia and approximately 50 miles south of Seattle. From I-5 take exit 114 and follow the signs.

Mima Mounds (84)

The Mima Mounds, 15 miles south of Olympia, is a rather unique location. The "mounds" are regularly spaced humps, 6 to 8 feet tall,

Wood duck, Nisqually National Wildlife Refuge

that no one has yet been able to explain; their origin is a mystery.

But the main attractions here for photographers are the butterflies (18 species) and wildflowers found in this remnant of the Puget Prairie. Bring your close-up gear, tripod, reflector, diffuser, and flash to help capture it all. Be sure to pack a wide-angle lens to record the overall view of this strange landscape. (See site #2, the Seattle Science Center Tropical Butterfly Exhibit, for tips on photographing butterflies.)

The prime time for flowers and butterflies is mid- to late May, though different species of flowers bloom throughout the summer.

Pro Tip: When photographing butterflies, try staying with the same individual. It may get used to you and let you get closer. Also, avoid casting your shadow on the butterfly, which will just make it flutter away.

Directions: From I-5 south of Olympia, take exit 95 to SR 121. Drive about 3.7 miles west past Littlerock Elementary School to the Waddell Creek Road. Turn right, and drive another 0.8 mile to Mima Mounds. There are rest rooms on site.

Kitsap Peninsula

19

101 104

88 Point No Point

*Puget
Sound*

Hood Canal

90 Port Gamble
View

Port
Gamble 89

92 Kitsap Memorial
State Park

3 Kingston

*Dabob
Bay*

104

*Port Madison
Indian Reservation*

87 Poulsbo
Poulsbo Suquamish

Brinnon *Bangor
Naval
Reservation*

305

93 Bainbridge Island / Bloedel Reserve

101

Scenic Beach State Park
91

305

303 *Bainbridge Island*

Silverdale

Seattle →

Hood Canal

Hood Canal

*Dyes
Inlet*

N
5 MILES

NW Seabeck Holly Rd.

Central Valley Rd. NW

3

Ferries
View
94

Ferry Routes

Bremerton
85
Bremerton

Washington

86 Port Orchard
Elandan
Gardens

3 16

Paul Woodward, © 2007 The Countryman Press

IV. Kitsap Peninsula

The Kitsap Peninsula lies between Puget Sound to the east and Hood Canal to the west. The Kitsap area doesn't get a lot of attention from photographers, but there is a lot to photograph here nevertheless.

Access the Kitsap Peninsula from either the Seattle or Edmonds ferries. You can also drive across the Tacoma Narrows Bridge and follow SR 16.

Bremerton (85)

A pleasant one-hour ferry ride from Seattle, Bremerton is the largest city on the Kitsap Peninsula and the home of the Puget Sound Naval Shipyards, the primary employer in the area. Recently Bremerton has been undergoing a revitalization of its downtown and waterfront. There are new sculptures, new fountains, a new conference center, and a new vitality.

Of particular interest to the travel-oriented photographer is the Bremerton Harborside, adjacent to the ferry dock. What you'll find are a series of fountains and public artwork, including *The Proud Tradition* by sculptor Larry Anderson.

Of special interest is a stair-stepping fountain with water that leaps from one level to the next in steady streams reminiscent of glass tubes. From the stairs next to this fountain you can get pictures of the fountain with a docked ferry in the background. A normal to short telephoto lens, like a 24–120mm zoom, works great here.

At this writing, a Waterfront Park between the ferry dock and the Puget Sound Naval Shipyards is under construction. With five fountains—which will be lit at night—trees and boulders, and close-up views of docked ferries, this park promises to be a great addition to the city. If you visit Bremerton, be sure to investigate both sides of the ferry dock.

Across Sinclair inlet on **Beach Drive in Port Orchard** there's a good place to set up to get early-morning shots of Bremerton (with or without a ferry) and the Manette Bridge with the Olympic Mountains rising from behind. This shot is best in late fall, winter, or early spring when the mountains are full of snow. This is also a good place for photographing the ferries coming and going.

Directions: From Seattle, drive south on I-5, and take the SR 16 exit (exit 132) to Bremerton (you'll cross over the Tacoma Narrows Bridge). Continue on SR 16 until it joins with SR 3, and follow the signs to Bremerton. From Poulsbo, drive south on SR 3 to the Kitsap Way exit in Bremerton. Turn left, and follow Kitsap Way, which will become Sixth Street. Sixth will take you into downtown Bremerton. Parking can be found on the streets, in pay parking lots, or in area parking garages.

To reach Beach Drive from Bremerton, take SR 3 south. Get in the left lane, and exit at Port Orchard. Drive all the way through town, following SW Bay Street. At an intersection with Bethel Avenue, turn left, continuing on Bay Street. Drive another 1.6 miles to a wide pulloff on the left.

Elandan Gardens (86)

Hidden in plain sight on the head of Sinclair Inlet and just off SR 16, Elandan Gardens is a gem of a place to spend an afternoon photographing and admiring what truly gifted artists can do. Dan Robinson, who has been called the "Picasso of Bonsai," has created a beautiful and peaceful place in which to display his collection of over two hundred bonsai (some over

a thousand years old). Dan's son, Will, is a talented stone sculptor, and his work is displayed throughout the gardens.

In May the rhododendrons and azaleas are in full bloom. In October the many Japanese maples add a blaze of fall color. A pond, featuring tall boulders that resemble standing stones, is bordered on one side by Japanese maples.

Wide-angle lenses are great for photographing the general landscape and the pond. Pull out your macro gear to photograph the patterns and swirls of the ancient trees. If you see a basset hound, that's Sushi. Any lens will work for her.

Admission to the garden is $5 (and it's well worth it). The staff is very photographer friendly, and tripods are allowed. They only ask that if you publish your images, you do

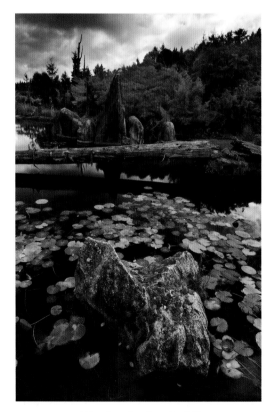

Elandan Gardens in fall

your best to make sure that they are identified as having come from Elandan Gardens.

Directions: From Tacoma, drive west on SR 16 toward Bremerton. Just past mile marker 28 look for the entrance to Elandan Gardens. From Bremerton, drive south on SR 3 as it becomes SR 16. Go past Elandan Gardens, and take the Tremont Street exit. At the bottom of the off ramp, turn right, go under the freeway, and get back on SR 16. Follow the directions as above.

Poulsbo (87)

The town of Poulsbo has a strong Norwegian heritage as evidenced by street names such as Lindvig, Torval, and Edvard. Every May, near the 17th, **Viking Fest** brings out the Norse in everyone. If you enjoy travel photography, you might just have a great time here.

Downtown Poulsbo, on Liberty Bay, is a collection of coffee shops, art galleries, bookstores, candy shops, boutiques, and gift shops all packed into a couple of blocks. Across the bay there's a great shot of the marina with Mount Rainier right behind it. From downtown Poulsbo drive north on Front Street and follow it as it drops down to the head of Liberty Bay. Keep left onto Lindvig Way. At Viking Way turn left, drive about 0.5 mile, and turn left again into the Liberty Shores Assisted Living parking lot. Parking is to the left as you drive in. Walk on the left side of Liberty Shores to a gate and a stairway leading down to the public-access beach. From here you have a pretty good view of the marina with Mount Rainier right behind it. The view gets better if you turn left and walk north.

For the best telephoto effect, use a long lens in the 300mm to 400mm range. You'll likely need to use a polarizer to help cut atmospheric haze and glare off the water. For the best light on the marina and the mountain, late afternoon is best.

Poulsbo marina and Mount Rainier, late afternoon

For a view across the bay, continue south on Viking Way another 0.75 mile, and turn left on Sherman Hill Road. This short dead-end road leads right to the water and a view straight across to downtown Poulsbo. You could shoot here almost any time of day if it's overcast; otherwise, it's more of a late afternoon shot.

Directions: To get to Poulsbo from Seattle, catch the ferry to Bainbridge Island, and take SR 305 into Poulsbo. At NE Hostmark Street, turn left. This will take you into downtown Poulsbo. You'll find parking on the street, or take any of the next four left-hand turns into the parking lot next to the marina.

Point No Point (88)

The lighthouse at Point No Point is easy to get to and makes a great sunrise or sunset photo location. From the parking lot, just walk along either the sidewalk or the beach to approach the lighthouse. You can photograph from either side, depending on the dictates of the light or your whims. Along the beach, look for driftwood or beach grasses to act as foreground for wide-angle shots.

Directions: From Seattle, take the ferry to Bainbridge Island, and follow SR 305 through Poulsbo. In Poulsbo turn right on Bond Road for 6.7 miles, and turn left on Hansville Road. Follow Hansville Road 7.4 miles, and turn right onto Point No Point Road. The lighthouse is at the end of the road. There's a parking lot with portable toilets.

Port Gamble (89)

Port Gamble, an old mill town near the mouth of Hood Canal, is one of the few remaining examples of a "company town." Founded in 1853 by William Talbot and Andrew Pope and designed to resemble the founder's hometown of East Machias, Maine, Port Gamble is now a rather attractive tourist town complete with museum, general store, an old church, and New England–style homes. Elm and maple

trees line the streets, making this a great photographic location in the fall.

On the bay side of the museum and general store are displayed an old anchor, a bell, a stone mill wheel, and a colorfully painted old steam-driven water pump. The pump is especially interesting to photograph. Get close, and take shots of the details.

Saint Paul's Church is on the south side of town and is very photogenic, especially in the autumn when you can frame the steeple with the fall foliage of the roadside trees. In the summer this is best shot early morning. In the fall a large tree shades the church, making this a better midmorning shot.

Directions: From Seattle, take the Bainbridge Ferry. Follow SR 305 through Poulsbo, turn right (north) onto Bond Road NE for 5.3 miles, and then turn left onto SR 104. Follow SR 104 into Port Gamble. From the Edmonds/ Kingston ferry, follow SR 104 through Kingston. In 3.9 miles SR 104 makes a right-hand turn. Keep following SR 104 to Port Gamble.

Port Gamble View (90)

A good view of Port Gamble and the church can be had from across the bay at a cemetery across from the S'Klallam tribal offices and school. You'll see an opening in the fence, a sort of wooden arbor/threshold. From just to the right of this you can see Saint Paul's Church across the bay. The view is OK right from the road, but it's a little better from just inside the fence. You'll need a long lens for this shot, at least 300mm to 400mm.

Directions: From Port Gamble, follow SR 104 back toward Kingston. In about 5.2 miles, turn left (north) on the Hansville Road. (This is the same road you'd take to Point No Point) In 2 miles turn left onto Little Boston Road. In 2

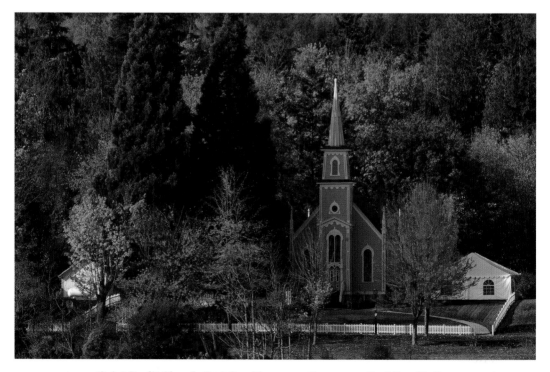

Saint Paul's Church, Port Gamble, as seen from across Port Gamble Bay

miles more, just at a bend in the road, park at the tribal offices.

State Parks

A couple of state parks along the Kitsap side of Hood Canal have fantastic views of the canal and the Olympic Mountains. Both of these locations are good spots for sunrise.

Scenic Beach State Park (91)

Scenic Beach State Park looks across Hood Canal to the Dosewallips and Duckabush Valleys and the peaks of the Olympic Mountains. There are also trails through the woods, a rustic bridge, and in the springtime rhododendrons add color to the forest. You can photograph sunrise on the distant peaks here any time of the year, but be here in May for the rhododendrons. Park at the end of the park road, and walk the short distance to viewpoints on the beach.

Kitsap Memorial Park (92)

Farther north, Kitsap Memorial Park—which is mainly a family recreation park—is another good place to photograph the mountains and the canal at sunrise. Also watch for the occasional bald eagle, seal, or submarine.

Directions: From the Hood Canal Bridge, take SR 3 south for 3 miles, and turn right into the park. From Poulsbo, take SR 3 north about 4.25 miles, and turn left into the park.

Bainbridge Island

Bainbridge Island is just a short ferry ride from Seattle and offers some great views of the ferries as well as one of the best nature reserves in all of Washington.

Bloedel Reserve (93)

Bloedel Reserve on Bainbridge Island is 150 acres of ponds, gardens, and native woodland.

Bloedel Reserve on Bainbridge Island

Here, too, are a bird refuge, a Japanese garden, a waterfall, and a moss garden, among other delights. Consider it a nature-photographer's playground.

It's possible to use every lens in your arsenal here. I particularly enjoy photographing the curving pathways or fall foliage reflected in the ponds. The large pond of the bird refuge has some very attractive shoreline curves, as well, with large willows overhanging one end of the pond.

This is a private reserve, not a public park. You'll need to make reservations, and admission is $10 per person. If you live in the Seattle area and think you may want to spend more time here, annual memberships are available. For reservations or information call 206-842-7631, or visit www.bloedelreserve.org.

Directions: From Seattle, take the ferry to Bainbridge Island. Drive north on SR 305

toward Poulsbo. In approximately 6.2 miles turn right onto Agatewood Road. In about 0.3 mile turn right on Dolphin Drive for 0.5 mile to the gatehouse at Bloedel Reserve. From Poulsbo take SR 305 south. Cross the Agate Pass Bridge to Bainbridge Island. At 0.6 mile past the end of the bridge, turn left on Agatewood Road, and follow the above directions.

Photographing Ferries from Bainbridge Island (94)

There are a number of good locations from which to photograph ferries as they ply Puget Sound on their way to and from Seattle, Bremerton, and Vashon Island.

As you depart the ferry from Seattle, get in the left-hand lane, and turn left at the first light onto Winslow Way. In two blocks turn right onto Madison and then left again onto Wyatt Way. In about 0.9 mile turn left on Eagle Harbor Drive. In 2.6 miles Eagle Harbor Drive becomes Rockaway Beach Drive. Follow for about 1 mile, and look for a small parking area on the left and a sign for **Rockaway Beach Park**.

This is a great spot for photographing ferries using Seattle as a backdrop.

A closer view of the Bremerton ferry can be had from a point on the south side of Bainbridge. Continue on Rockaway Beach Drive as above, which becomes Halls Hill Road. In about 0.7 mile turn left on Blakely Hill Road, which becomes Blakely Avenue. Turn left on Country Club Road. In about 0.8 mile turn right on Toe Jam Hill Road.

In about 1.25 miles, this road leads to South Beach Drive, where it makes a sharp right-hand turn and offers a fantastic view. Keep driving to where the road takes a sharp right-hand turn followed by a sharp left. You should be able to find parking along the shoulder. It's a very short walk back to South Beach Drive, and you don't have to go far at all to set up. The view south from here includes Vashon Island and Mount Rainier. In the distance you'll see the Vashon ferry making its way back and forth to the Fauntleroy dock in West Seattle.

To time your visit, consult the Bremerton ferry schedule, and try to pick a time when the ferry will come by right around sunset. From either Seattle or Bremerton, allow the ferry about a half hour from scheduled departure time to reach this point. An 80–200mm zoom lens works well here, though if you have a 300mm, bring it along, too.

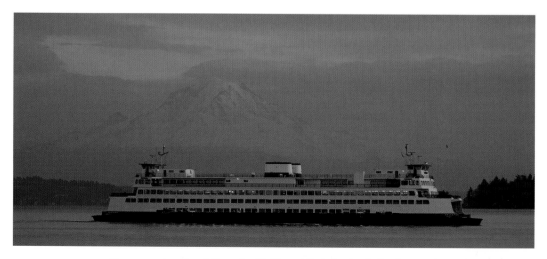

Ferry crossing Puget Sound with Mount Rainier in the background

V. The Olympic Peninsula

Away from the hustle and bustle of the Puget Sound metropolis, Olympic Peninsula is packed with scenic beauty, pristine beaches, wilderness trails, and lush forests. It's on many a nature photographer's "must visit" list, and it's one of my favorite places on earth. That's why I live here.

Port Townsend Area

SPRING ★★★ SUMMER ★★★
FALL ★★★ WINTER ★

A popular bumper sticker seen around town reads WE'RE ALL HERE BECAUSE WE'RE NOT QUITE ALL THERE. That pretty much sums up Port Townsend (or as we call it, PT). Some interesting people live here, including Leonard "the Bamboo Man," known for his deep knowledge and love of bamboo as well as the fact that he grows dozens of varieties on his property. If you need bamboo, Leonard's your guy. (He also holds the Guinness World Record for the longest eyebrow hairs, but that's another story.)

There is much to see and photograph in this historic Victorian seaport, including old Victorian homes, a working boatyard, the downtown area, a lighthouse, and a World War II–era fort.

Directions: From the western end of the Hood Canal Bridge, follow SR 104 for 5 miles, and turn right onto SR 19. Follow SR 19, which merges with SR 20, approximately 19 miles into Port Townsend.

Victorian Homes (95)

Most of the Victorian homes are in the Uptown area Port Townsend, many of them now housing local businesses or serving as hotels or B&Bs. Follow SR 20 into town. It becomes Water Street as you reach the historic downtown area. Drive through town, which will give you an initial overview of what the downtown area is like, and turn left onto Quincy Street near the far end of town. Follow Quincy as it turns left and becomes Jefferson Street, and then turn right onto Tyler. This will take you into the heart of the Uptown area on Lawrence Street.

A good starting point is the Ann Starrett Mansion, now a boutique hotel. You'll find it on the corner of Clay and Adams. From Lawrence Street, head back down Tyler, turn left onto Clay Street, and go two blocks to the Ann Starrett Mansion.

To find other houses to photograph, I suggest simply driving or walking around this general area.

The Jefferson County Courthouse, built in 1892, is also a good photo subject. You'll find it on Jefferson Street between Walker Street and Cass Street. You shouldn't have any problem finding it; its distinctive clock tower is hard to miss.

Downtown Port Townsend (96)

As is the case with the Victorian homes in the Uptown area, your best bet here is to simply walk up and down Water Street and see what catches your fancy. The Lewis Building at Madison and Water Streets has an old "Genuine Bull Durham" advertisement painted on its brick side. Elevated Ice Cream, across from the Lewis Building, is an old-fashioned ice cream parlor and candy shop. In fact, it made the Travel Channel's list of World's Best Ice Cream Parlors. The exterior is worth a quick shot, but the real goal here is the ice cream, which is all made on the premises.

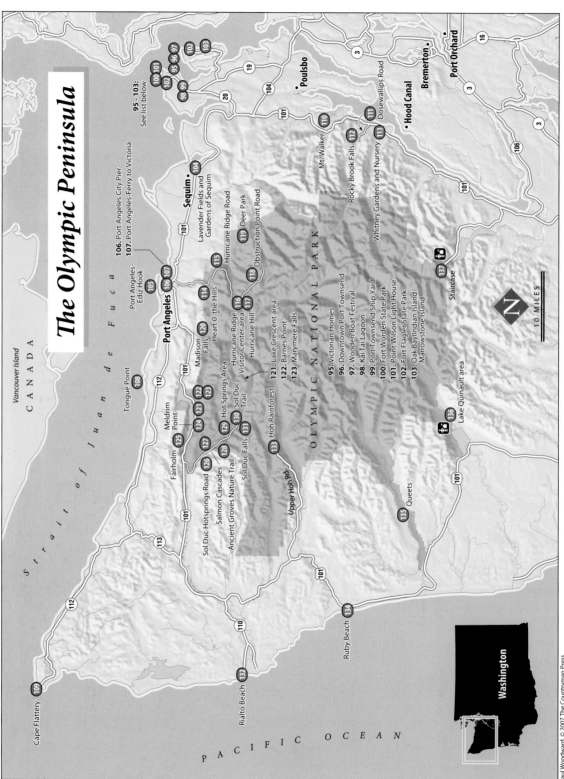

The Olympic Peninsula

CANADA

Vancouver Island

Tongue Point

Strait of Juan de Fuca

Cape Flattery **109**

PACIFIC OCEAN

95 - 103:
See list below.

106. Port Angeles City Pier
107. Port Angeles-Ferry to Victoria

Port Angeles-
Ediz Hook

105

104

Sequim •

Lavender Fields and
Gardens of Sequim

106 107

Port Angeles

Poulsbo

3

19

20

104

101

Bremerton •

Port Orchard •

16

16

3

3

106

101

• Hood Canal

Dosewallips Road

Whitney Gardens and Nursery **113**

111

112

Rocky Brook Falls

110

Mt. Walker

Hurricane Ridge Road

Deer Park **119**

Obstruction Point Road **118**

115

Heart O' the Hills **120**

114

Madison
Falls

116

Hurricane Ridge
Visitor Center area **117**

Hurricane Hill

OLYMPIC NATIONAL PARK

95. Victorian Homes
96. Downtown Port Townsend
97. Wooden Boat Festival
98. Kai Tai Lagoon
99. Port Townsend Ship Yard
100. Fort Worden State Park
101. Point Wilson Light House
102. Fort Flagler State Park
103. Oak Bay/Indian Island/
Marrowstone Island

121. Lake Crescent area
122. Barnes Point
123. Manymere Falls

137

Staircase

136

Lake Quinault area

135

Queets

101

101

Hot Springs Area

122

123

Sol Duc
Trail

130

131

Meldrim
Point

124 **121**

125

Fairholm

127

Sol Duc Hotsprings Road

126

Salmon Cascades

Ancient Groves Nature Trail

128

Sol Duc Falls

129

Hoh Rainforest

133

Upper Hoh Rd.

134

Ruby Beach

132

Rialto Beach

112

110

101

113

N

10 MILES

Washington

Paul Woodward, © 2007 The Countryman Press

Wooden Boat Festival (97)

If you're into wooden boats, consider showing up for Port Townsend's Wooden Boat Festival, which happens the second weekend of September. There will be races, boatbuilding demonstrations, music, and of course, wooden boats. Visit www.woodenboat.org for specific dates and details.

Kai Tai Lagoon (98)

The Kai Tai Lagoon is located right in the middle of town and encompasses some 80 acres of natural area, including 25 acres of open water and 15 acres of wetlands. A trail follows the south edge of the main lagoon. Nesting boxes have been erected to accommodate the waterfowl that breed here. Situated along the Pacific Flyway, Kai Tai plays host to quite a variety of birds including green-winged teal, Cooper's hawk, great blue heron, northern flicker, cedar waxwing, and red-winged blackbird.

If you do come here to photograph birds, the best times are early morning or early evening.

Directions: Entering Port Townsend, turn left at the Safeway and then right onto 12th Street. A parking lot is located off of 12th Street, behind the McDonald's and Henery's Hardware.

Port Townsend Shipyard (99)

Across from the Safeway is the Port Townsend Shipyard. Here you'll find a variety of fishing boats in dry dock being renovated, repaired, or maintained. Photograph details and people working on the boats. Then wander north to the marina; sunny mornings can be good for reflections, and foggy mornings are good for mood shots. There's parking along the waterfront.

Fort Worden State Park (100)

Fort Worden State Park is one of three artillery forts built in the early 1900s to protect Puget Sound. The others are Fort Casey to the east, on Whidbey Island, and Fort Flagler to the south, on Marrowstone Island. Today Fort Worden is one of the most popular parks in the state.

For me the most interesting things to photograph here are the shapes, colors, and textures of the old batteries on **Artillery Hill**. You wouldn't think that old concrete and steel would be appealing photo subjects, but to anyone who likes photographing graphics or old things, the artillery batteries can be quite attractive.

You'll want to take some overall pictures using a wide-angle lens, but the real fun begins when you pull out a medium telephoto like an 80–200mm zoom and start picking out details. Some things to look for include iron rings attached to a concrete wall, stairways, and rust patterns on doors.

One great thing about this location is that it works in any kind of light. On overcast days you'll have even lighting and no real contrast problems. On sunny days you'll have harsh shadows that you can actually use as graphic elements. For example, the shadow cast by concrete stairs is a black zigzag. The shadow

Concrete stairway on Battery Hill,
Fort Worden State Park

Iron ring on concrete wall, Fort Flagler State Park

Point Wilson Lighthouse (101)

When you enter Fort Worden State Park, turn right at the first crossroad, Eisenhower Avenue, and drive to the east end of the parade ground. Turn left, and drive to the end of the road.

Since the lighthouse is situated on a small peninsula pointing to the northeast, and the beach falls away to either side, you have several ways to approach this shot. Walk down either beach to see the possibilities.

From near the lighthouse itself, try a wide-angle lens. From the south side, you can use the fence as a leading line. If you're close to the lighthouse at sunrise, try including the sun reflecting in one of the windows.

Another option is to photograph the lighthouse from a parking lot that's just up the hill from the main parking lot. This is more of a mid-telephoto shot, though you could use a long lens in the 300mm to 400mm range to isolate just the top of the lighthouse.

Fort Flagler State Park (102)

Fort Flagler State Park sits on the north tip of Marrowstone Island, just across Port Townsend Bay.

Of the three forts, the artillery batteries of Fort Worden definitely offer more variety. But if you're looking for wildlife or good views of two of the region's major mountains, then Fort Flagler gets the nod.

Located on the Pacific Flyway, Fort Flagler State Park is well-known to local birders. The shore birds are easier to photograph because they're out in the open, and a dedicated bird photographer could do well here.

The two places that are best for wildlife viewing are **Marrowstone Point** at the northeast corner of the park, and a **sand spit** on the northwestern corner. When you drive into the park, you have the choice of going right, left, or straight. If you turn left, the road will take you down to a wide-open camping/picnicking area

cast by an iron ring is a repeated curve. See? You can't lose.

To visit Artillery Hill, the first thing you should do is pick up a map from the park office, which is located in the park on Eisenhower Avenue right across the street from the flagpole. To get to the artillery batteries, return to the first main intersection and turn right. Keep on this road as it veers to the left and ends at a gate. From here you'll need to walk. In a short while the road splits. Turning to the right will take you up to Battery Hill. It's about a 0.5 mile, slightly uphill walk.

Directions: As you enter Port Townsend, turn left on Kearney Street; it's the first light after the Safeway and McDonald's. You'll see the sign to Fort Worden State Park. At Blaine Street turn right. Then turn left on Walker Street, and follow the signs to the park.

on the water. Park at the end of the road, and walk south along the spit. Harbor seals can often be seen here at low tide, and this is also a good spot for shore birds.

If you drive straight into the park, follow signs to Marrowstone Point. The view from this beach includes Whidbey Island and Mount Baker to the northeast and Mount Rainier to the south.

Directions: From the Hood Canal Bridge, follow SR 104 west 5 miles, and turn right onto SR 19 toward Port Ludlow and Port Townsend. Drive 1.7 miles, and turn right onto Oak Bay Road. Follow Oak Bay Road through Port Ludlow 9.9 miles to SR 116, Flagler Road. Turn right onto SR 116. Fort Flagler is at the end of the road (8.6 miles).

Oak Bay/Indian Island/Marrowstone Island (103)

When you turn onto SR 116 from Oak Bay Road on the way to Fort Flagler, you'll cross a bridge to Indian Island. About 0.7 mile beyond the end of the bridge, on the right, is a road leading to an unnamed park. Turn into the park at the Jefferson County Park sign, and follow the road to a parking lot near the beach. The view from here looks out on Oak Bay, with Mount Rainier in the far distance. There is some good foreground material here in the form of a small island a few feet offshore.

If you've got a long telephoto lens in the 400mm to 600mm range, keep it handy for any birds that may be about. This entire area is good year-round for birds but best in spring and summer.

Continuing on SR 116 (Flagler Road) toward Fort Flagler, you'll soon come to the narrow isthmus where Indian Island and Marrowstone Island meet. The tidelands on either side of the road present good bird habitat, and there's a pullout here, so you can stop and check the area out with your binoculars.

North Olympic Peninsula

SPRING ★★ SUMMER ★★★★
FALL ★★ WINTER ★

The north Olympic Peninsula area contains some wonderful photo opportunities, including lavender farms and the best tide-pool area in the state. You'll find fantastic views of the Straits of Juan de Fuca as well as some interesting industrial areas. Because I've dedicated an entire chapter to Olympic National Park, those sites won't be included here.

Lavender Fields and Gardens of Sequim (104)

There are more than 36 lavender growers in the Sequim Valley, which is on the way from Seattle to Port Angeles. In summer the lavender fields in Sequim (pronounced "squim") become rolling waves of purple, presenting photographers with endless landscape, close-up, graphic, and abstract possibilities. Sequim, being in the "rain shadow" of the Olympic Mountains, gets very little rainfall, which makes for perfect lavender growing conditions.

The **Sequim Lavender Festival** is typically the second weekend in July. Because of the crowds—and the limited parking due to those crowds—I'd suggest visiting either before or after the festival, preferably just before because much of the lavender is harvested later in the month. Parking at all the lavender farms is free except during the Lavender Festival. For more information and to download a festival brochure containing a map to the farms, visit www .lavenderfestival.com.

Two of my favorite lavender farms are:

Jardin du Soleil:
The lavender fields, flower gardens, and the eclectic collection of found objects such as an ancient, lichen-covered swing bench, numerous and varied bird houses, and a squirrel "ho-

tel," make Jardin du Soleil my favorite lavender farm to photograph.

Try using long lenses to isolate things like the lavender-colored Adirondack chairs. Or look for single yellow sunflowers growing in the midst of the purple lavender—this is a great color contrast, and these kinds of pictures will pop. Be sure to look at the flower gardens near the greenhouse. A piece of old farm equipment serves as a planter box. Try including the distant Mount Baker in the photo, as well.

Owners Pam and Randy Nicholson are very photographer friendly; they only ask that if you publish any pictures taken from their farm that you do your best to make sure the photos are identified as being taken at Jardin du Soleil.

Directions: Take the Sequim Avenue exit off US 101, and turn north onto Sequim Avenue, which becomes Sequim-Dungeness Way. Drive north for approximately 4.5 miles. Jardin du Soleil is on the right, just north of the Dun-geness Community Church. Hours are 10 to 5 or by appointment.

Purple Haze:
Of all the lavender farms in Sequim, Purple Haze is the best known. Here you'll find rolling fields of lavender, flower gardens, and many good photo opportunities.

Directions: Traveling toward Sequim from Seattle, take the Washington Street exit, and drive 1.3 miles to W Sequim Bay Road. Turn right, drive approx. 0.9 mile, and turn right again on Bellbottom Road.

Port Angeles

Because most photographers are here to photograph in Olympic National Park, they miss out on the photo opportunities to be found right in Port Angeles. While you're here visiting the park, be sure to take some time to check out the town.

Jardin du Soleil Lavender Farm

Ediz Hook (105) offers extremes in photographic subject matter. At the intersection of Front Street and Lincoln Street (where US 101 makes a sharp turn), drive west on Front Street through downtown. In a couple of blocks, Front becomes Marine Drive. Stay on Marine Drive, and it becomes Ediz Hook Road. You'll pass through an **industrial area** and come to a series of large white storage tanks. Each tank has a staircase spiraling up its side. This is a great noontime, sunny-day location, and there aren't too many of those. On bright days these staircases, along with the shadows they cast, make for wonderful, graphic subjects. An 80–200mm zoom is ideal here.

For a **view of town and the mountains**, drive to the end of the Ediz Hook Road, and look back toward Port Angeles. On a clear day you can get some nice shots of the city with the mountains rising behind.

The **City Pier (106)** is located at the north end of Lincoln Street on the waterfront. Here you'll find flower displays and sculptures, including a whimsical moss-covered octopus. From the viewing tower at the end of the pier, you get a good view of the city and harbor.

Looking for more to do? Hop the **ferry to Victoria, B.C. (107)**, and spend a day in Canada. Things to do in Victoria include visiting Butchart Gardens, the Victoria Butterfly Garden, and museums as well as sightseeing and shopping (handy if you're traveling with a nonphotographer spouse). The car ferry to Victoria departs twice daily in the summer. The passenger ferry departs four times daily from mid-July through early September.

For information on fares and schedules, visit www.cohoferry.com for the car ferry and www.victoriaexpress.com for the walk-on ferry.

Directions: From downtown Seattle, take the Bainbridge Island ferry, and follow SR 305 to Poulsbo. Follow signs to SR 3, drive north, and

Oil tanks on Ediz Hook

join SR 104 at the Hood Canal Bridge. After 15 miles SR 104 joins US 101. Follow US 101 about 35 miles to Port Angeles.

Tongue Point (108)

West of Port Angeles, is the **Salt Creek Recreation Area** and Tongue Point. Tongue Point is arguably the premier location for tide pool photography on the peninsula.

A word of caution is in order here: *Be very careful.* Seashores, by their nature, are not the safest places, and this location is no exception. The seaweed is slippery, the rocks are sharp, and footing is precarious. Just go slow, wear sturdy footwear, and be careful. Use your tripod as support if you need to. And don't let yourself or your expensive equipment get soaked because you weren't paying attention to the incoming tide.

First of all, you need to know when to visit. Consult a tide table or an online resource such as saltwatertides.com. The tide station you

Blood star in anemone, Tongue Point

need to reference is Crescent Bay. The best low tides are typically in May, June, and July. I'll usually start making my way out to the tide pools as much as an hour or so before the predicted low tide. There will be plenty of tide pools to work with by then, and you'll have a good two hours or more to play.

When I go I typically use only my 105mm macro lens, though for some reason I always seem to bring my entire pack. Don't ask. If I had a 200mm macro lens, I would bring that instead. A tripod is a must if you want to get quality tide pool pictures. Other things you'll want to bring are polarizers and a diffuser. A black umbrella will also come in handy. Use it to block the bright sky. Another very useful accessory is kneepads or a piece of closed-cell foam. Those rocks and barnacles can cause

some real pain, and you're going to need to get down low for most of your shots.

Salt Creek is also a good place for both sunrise and sunset in the summer; the sun will be rising and setting in the northeast and northwest, respectively.

Directions: From Port Angeles, drive west on US 101 for about 5 miles to SR 112. Follow SR 112 for 7.3 miles, and turn right onto Camp Hayden Road. Take Camp Hayden Road for 3.5 miles to the entrance of Salt Creek Recreation Area County Park. Follow the park road as it passes a large camping area and enters the trees. You'll pass several more campsites. Look for the day-use parking areas; there are two of them. You can access the tide pools from either one, but the shortest route is probably from the far parking lot. Stairways lead down to the rocks; from there, carefully make your way to the tide pool areas.

Cape Flattery (109)

Cape Flattery is the most northwestern point in the continental United States. The trail, much of it a boardwalk, leads 0.75 mile through spruce forest to some rather impressive views. Along the way you'll come across several nice scenes, including what a friend of mine calls the Hobbit Tree, a candelabra-shaped tree next to the curving boardwalk. If you're lucky enough to be on this trail while the forest is shrouded in mist, this would be a magical scene. Of course, if the forest *is* in mist, chances are the spectacular views at the end of the trail will be obscured. But let's assume that we live in a perfect photo world and that you can photograph the forest in mist *and* get the spectacular views. (I sometimes live in a fantasy world.)

At the end of the trail you're 100 feet above the ocean, and the views include cliffs to both sides and Tatoosh Island off the coast. Bird life is abundant; there's a good chance you'll see

tufted puffins, rhinoceros auklets, bald eagles, and oystercatchers, among others. You'll need a long lens to get decent images from here.

The **Cape Flattery Lighthouse** is just offshore on **Tatoosh Island**. A long lens in the 300mm range works best. It can get windy here, so be aware of any vibrations.

Directions: From Port Angeles, take US 101 west. Five miles past Port Angeles, turn right onto SR 112, and stay on it for 60 miles to Neah Bay. Following signs to Cape Flattery, take a right at the IHS Clinic/Presbyterian Church—go one block, turn left, and follow the signs to the Makah Tribal Center (about 2.5 miles). Go past the tribal center, and in 0.25 mile the road will change to gravel. Continue on the gravel road for approximately 4 miles to the Cape Trail; stay to your left, and drive a short distance to the parking lot.

You'll need to get a $10 annual recreation pass while on Makah land. These are available at most businesses in Neah Bay as well as the Makah Tribal Center and Makah Museum. For more information visit: www.makah.com/cape.html.

Hood Canal Area

SPRING ★★★★ SUMMER ★★★
FALL ★★ WINTER ★

Hood Canal is the narrow body of water between the Kitsap Peninsula and the Olympic Peninsula. But it's actually a fiord, not a canal, and it's home to the largest octopuses in the world. I suppose that helps if you're an underwater photographer. For us land-based shooters, the springtime bloom of the native rhododendrons add a colorful accent to the towering evergreen trees.

Mount Walker (110)
Mount Walker, elevation 2,804 feet, is a great place for rhododendrons in the spring and stunning views year-round.

When you get to the top you have the choice of the North or South Viewpoints. The two viewpoints are relatively close to each other, and short trails lead from the parking areas to the lookouts themselves, so it's real easy to take a quick look at each to see which is best for you. The South Viewpoint has a wider expanse

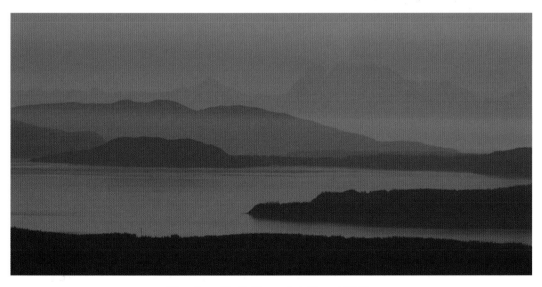

View from North Viewpoint, Mount Walker

(about 70 degrees). From this viewpoint you can see Mount Rainier as well as Tacoma and Seattle; on a clear day you can see the Seattle Space Needle. From the North Viewpoint you can see Port Townsend, the San Juan Islands, and Mount Baker. I'd recommend longer lenses for the viewpoints. This isn't to say that there aren't any good wide-angle shots to be had, just that there may be more possibilities by pulling out a 80–200mm zoom or a 300mm lens.

Sunrise can be magical at these heights. Hood Canal is often shrouded in mist or fog, with Mount Rainier floating in the far distance. The red hues of sunrise often reflect on the water below.

May and June are prime times to drive the Mount Walker Viewpoint Road (or hike the Mount Walker Trail). The native rhododendrons are at various stages of blooming, depending on elevation. So if you're a little late for the lower elevations, just keep driving uphill. For photographing the rhodies, an overcast, misty, or even rainy day is best. The ideal situation is a light fog.

Directions: Mount Walker is 5 miles south of Quilcene on US 101. The Mount Walker Viewpoint Road is a 4-mile gravel road to the summit. The road is usually open from mid-April thru October. Note that the gravel road is narrow and steep and is not recommended for trailers or motor homes. Restrooms are located at both North and South Viewpoints.

Dosewallips Road (111)

The Dosewallips Road, which follows the **Dosewallips River**, takes you through some nice forest areas and past a spectacular waterfall. This road used to lead into the national park, but several years ago it was washed out at the 9.5 mile mark, and the National Park Service has yet to replace the washed-out section. This adds several miles to the start of one of the most popular hikes across Olympic National Park. Nevertheless, the road is still worth exploring. In the spring the greens of ferns, moss, and new growth on the trees are as good as any on the rainforest side of the peninsula. Spring flowers include red columbine, vanilla leaf, and trillium.

At mile marker 3 on the Dosewallips Road, there's a small bridge with a pullout on the west side. Take the trail on the north side of the road past the small power-generating building. The 100-foot-tall **Rocky Brook Falls (112)** gets a five-star rating from *A Waterfall Lover's Guide to the Pacific Northwest.*

At the base of the falls there's a jumble of boulders to negotiate. These can be slippery when wet, so use plenty of caution. Since this waterfall faces south, you'll have contrast problems on sunny days.

Try making your way to the opposite side of the stream and climb up a ways for different views of the falls.

Whitney Gardens and Nursery (113) is located just a few hundred yards south of the Dosewallips Road. Late April through May is a great time to photograph the various species of rhododendrons that bloom in this delightful garden. Besides the rhodies, you'll find a small stream, pathways, and other flowers to photograph. Wide-angle, normal, and short-telephoto lenses, along with macro lenses, will be the most useful here.

Be sure to have your polarizer handy to help cut any glare reflecting off of the foliage.

Garden viewing is 9 AM. to dusk. The nursery is open from 10 AM to 5:30 PM. Admission is $1, and it's on the honor system. Collection boxes are set up at the beginning of the trails.

Directions: Dosewallips Road is just north of Brinnon on US 101, about 0.6 mile north of Dosewallips State Park. Whitney Gardens and Nursery is located in Brinnon, right on US 101; Brinnon is about 11.5 miles south of Quilcene.

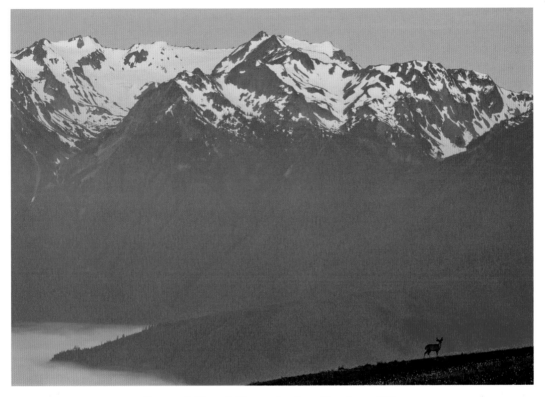

Deer and Olympic Mountains from Hurricane Ridge

Olympic National Park

SPRING ★ ★ ★ SUMMER ★ ★ ★ ★
FALL ★ ★ ★ WINTER ★ ★

Olympic National Park is said to be three parks in one. It is that—and more. In the forest you'll find huge trees, delicate flowers, classic waterfalls, and pristine rivers. The high country boasts magnificent mountain scenery, colorful wildflowers, mountain streams, and abundant wildlife. On the coast you can photograph sea stacks against a sunset sky, ethereal fogscapes, wild coastlines, and entire worlds in the tide pools.

At almost a million acres, including 73 miles of wilderness coastline, the park takes up a good portion of the Olympic peninsula. No roads cross the park; that's left to the backpackers. However, several roads lead into the river valleys, and two roads lead to the meadows of the high country.

I've been wandering this park every year for over 20 years, and it's still one of my favorite places to be, let alone photograph.

Directions: From Seattle, get to Olympic National Park by hopping a ferry and crossing the Hood Canal Bridge. Follow SR 104 to US 101 into Port Angeles and other park access points.

Heart O' the Hills (114)

Five miles past the park visitors center in Port Angeles you'll come to the entrance station. Just beyond is the Heart O' the Hills campground. Drive to the large parking lot near the amphitheater, and start exploring. At the far end of the

parking lot, on the opposite side from where you park and across from a picnic table, is an old stump partially covered with bunchberry (Canadian dogwood). In late May and early June, these will be in full bloom, and the setting is nearly perfect. Use your 80–200mm zoom to frame up a shot of these bunchberries against the wood.

Wander up and down the parking lot, and you'll find plenty to photograph in this lush forest.

The campground itself is a source of some excellent forest photography. In the spring it's not too crowded here, and you can get some great shots.

Hurricane Ridge Road (115)

Many people enter the park in Port Angeles and make for the visitors center at the top of Hurricane Ridge Road. If you only use the road as a way to get to the high country, you'll be missing out on some excellent photo opportunities. The paved road starts at the Olympic National Park Visitor Center in Port Angeles and climbs 17 miles and 5,000 feet to the Hurricane Ridge Visitor Center. The road is open 24 hours from mid-May to mid-autumn, when the snow starts to accumulate. During the winter (October through April), the road is open on weekends, weather permitting, and only from approximately 9 AM to dusk. If you plan to make a winter trip, be sure to call the recorded information line at 360-565-3131.

At several places along the road, you'll have magnificent views looking both north and east. Mount Baker, in the Cascade Range, is visible in some places along the road. One of my more colorful sunrise shots is of this mountain taken from one of the turnouts. One of the best spots for this is the turnout that's just before a pair of tunnels. This is approximately 9 miles from the Port Angeles visitors center.

From late spring through summer you'll be able to find lots of flowers along the road, especially as it gains elevation. There are plenty of pullouts along the road, so parking won't be a problem.

Along the way up to the top of the ridge are numerous views of the valley below, which is sometimes filled with morning fog. Often, low clouds flow over the nearby ridges. These can make for some painterly images as the clouds catch the pinks of the rising sun. Try longer exposures to record the flow of the clouds.

If you think you have the time to spare, I'd suggest spending at least two mornings at Hurricane Ridge: one at the top and the other on the road below. A good place to set up is just before you get to the parking lot. A pullout is on your left just before a guardrail. From here you'll be looking to the east down the Cox Valley. In the summer the sun will be coming up a bit to your left.

Hurricane Ridge is a must, and you could easily spend two or three days exploring the area. Both sunrise and sunset shots are possible here. When you get to the top of Hurricane Ridge Road, you'll find the **Hurricane Ridge Visitor Center Area (116)**. Many a great sunrise image has been made right from the viewing platform. Use telephoto lenses to feature only the mountains or wider lenses to take in the Elwha Valley below, which is often filled with fog.

From spending countless mornings here waiting for sunrise, I can tell you one thing for certain: When it happens, it happens fast. On clear summer mornings you can actually see the pink in the sky descending to the mountain peaks. Once it hits, the pink light doesn't last long.

A polarizer can really help to cut out any haze over the valley as well as to darken the sky.

If you're up for a short but steep hike, take the paved trail found at the east end of the parking lot and follow it to the right as it climbs

the hill. From the top of the hill, you'll have views of both the mountains to the south and the valley to the northeast.

Just because the pink light has passed and the surrounding meadows are beginning to light up, don't think you're done for the morning. This is perfect light in which to photograph Columbia blacktail deer. You'll usually find them hanging out near the visitors center.

You don't need a super long lens to get good deer shots here. They are often close enough for frame-filling shots with an 80–200mm zoom.

Sunsets from the top of the ridge can be spectacular. By wandering around you'll find some good locations, both looking to the northwest where the sun will be setting and to the southwest to catch the last light on Mount Olympus and the Bailey Range.

The flowers in the Hurricane Ridge area are usually at their peak in mid-July. Some species, like glacier lilies and avalanche lilies, bloom earlier—usually in June—but that often depends on the snow pack.

Actually, you won't find a whole lot of flowers near the visitors center and parking lot area. For whatever reason—maybe the deer eat them—there just aren't a lot of flowers in this area. But don't worry, you'll find plenty of flowers in other areas. It just takes a little walking or driving.

The Hurricane Ridge area is also fun to visit in winter. You can't get up there for sunrise because the road doesn't open until 9 AM, but you can remain until sunset. If you want to get around beyond the parking lot, you'll need snowshoes or cross-country skis. Follow the road beyond the visitors center toward **Hurricane Hill**, or wander the snowy meadows behind (to the north) of the visitors center. On a clear winter day the scenery here is stunning.

Beyond the visitors center **Hurricane Hill Road (117)** continues, and you can find wild-

flowers and different views of the interior of the park at several places along the road. At 0.6 mile beyond the visitors center, you'll see a trail on your left. By following this trail a short way, probably less than 0.25 mile, you stand a good chance of finding marmots, which are large, beaverlike rodents and are residents of the subalpine areas. You'll most likely hear their shrill whistles before you see them.

At the end of the road is the **Hurricane Hill Trail**. You don't have to walk too far on this trail to find wildflowers.

Just as you reach the top of the Hurricane Ridge Road, before you enter the parking lot, there's a road to the left that follows the rest of the ridge southeast to Obstruction Point. This is **Obstruction Point Road (118)**, a primitive dirt road unsuitable for trailers and RVs, but passenger cars will have no trouble with it. I

Olympic marmot (along Obstruction Point Road)

highly recommend exploring this road. It leads 7 miles to Obstruction Point, and you'll find plenty of pullouts and fantastic viewpoints along this road. You'll also see lots of glorious flowers, especially in mid-July. Depending on winter snowfall, the road is usually completely open by early July, though one year I had to hike the last half of the road.

At about the 5-mile point on this road, you'll come to a large field of purple lupine. (This is at the top of a long decline, so if you start heading down a steep hill, you've just passed it.) There's plenty of room to park on the side of the road. A trail climbs up a small bank and then leads into the field. Mount Olympus rises in the distance. This is a classic Olympic National Park mountain scene and a fantastic spot for wide-angle landscapes.

The road ends at Obstruction Point, where trails lead to **Deer Park, Badger Valley,** and **Grand Valley**. There's a pair of outhouses here; that's it as far as amenities go. The view, though, is spectacular, with Mount Olympus and the Bailey Range rising to the southwest. This is also a good place to find marmots.

A word of warning: In the summer, the horse flies can drive you nuts. They're relentless. They're evil. I hate them. Even on hot days I wear long sleeves to keep the buggers at bay. I also use insect repellant. The mosquitoes are no picnic either, but they're more bothersome in the forests.

Deer Park (119)

With possibly the best overall view that you can drive to in the entire Olympic National Park, Deer Park gets very few visitors compared to Hurricane Ridge. The vista north includes Port Angeles, Sequim, the Dungeness Spit, Port Townsend, the Strait of Juan de Fuca, the San Juan Islands, Vancouver Island, Anacortes, Mount Baker, and the North Cascades. The short, easy **Rain Shadow Trail**

loops around the summit where you can find views south into the interior of the park as well as plentiful flowers.

The best views, however, are right from the parking lot. Follow a short trail west, where you'll see a rock outcropping. This is a great place to set up for sunrise or sunset.

A telephoto lens comes in handy here. A 80–200mm zoom, a 300mm, or longer lenses work well for picking out parts of the landscape or isolating Mount Baker.

Directions: Deer Park Road begins about 5 miles east of downtown Port Angeles, next to the movie theater. After about 8.6 miles the pavement ends and becomes a narrow, winding dirt road not recommended for trailers or RVs. The road leads 16 miles to the primitive Deer Park campground and then continues the short distance to the top of **Blue Mountain** (6,007 feet). It's not open during the winter months but is usually open from mid-June to early October. Give yourself at least 45 minutes to drive to the top. Outhouses are available in the campground, and the ranger station is staffed in the summer months.

Madison Falls (120)

On your way from Port Angeles to Lake Crescent, be sure to stop and investigate Madison Falls. It's easy to get to, and easy to photograph. Madison Falls resembles Marymere Falls in many ways, though it's not as tall. Not many people seem to know about this waterfall, either, making it a lot less crowded than Marymere. It's also easier to get down to the stream and the base of this waterfall. If you do decide to get close, a wide-angle lens will be needed to take in the entire falls. Watch out for the sky; it will likely be very bright in the frame. Consider making some shots that eliminate the top of the falls. It's OK, you don't need to include the top; we all know the falls starts someplace.

You can use a telephoto lens to pick out

pieces of the falls, as well. This is fun to do. Use long shutter speeds to smooth out the water and to create an ethereal effect.

Directions: About 8.5 miles west of Port Angeles on US 101, right before a bridge, turn left into the Elwha River entrance to the park. Follow the road for a short distance, and park in the lot just beyond the entrance station. A flat, paved trail leads a short distance to the falls.

Lake Crescent Area (121)

Lake Crescent—which is 17 miles west of Port Angeles on US 101—is one of my favorite areas on the entire peninsula. The lake can be calm, stormy, moody, sun filled, or ethereal—and all on the same day! In the summer this can be a good place for either sunrise or sunset. In the middle of a sunny day, you can create some nice postcard-type images, as well.

US 101 follows Lake Crescent's southern shore. You'll find plenty of convenient pullouts from which to photograph. Take your time, and be sure to drive the road in both directions to get yourself familiar with the area.

One of the first places you'll see once you arrive is **Barnes Point (122)**. It's about 3 miles from where US 101 meets the east end of the lake. Here you'll find the **Lake Crescent Lodge**, the **Olympic Park Institute**, and the **Storm King Ranger Station**. Park at the ranger station, and take the short hike to **Marymere Falls (123)**, one of the most recognizable falls in the park.

The trail gets steep for a short distance as you approach the falls, but it's worth the effort. Marymere Falls is tall, and you can get close to it, so a wide-angle lens works well. There are two viewpoints from the trail: one below the

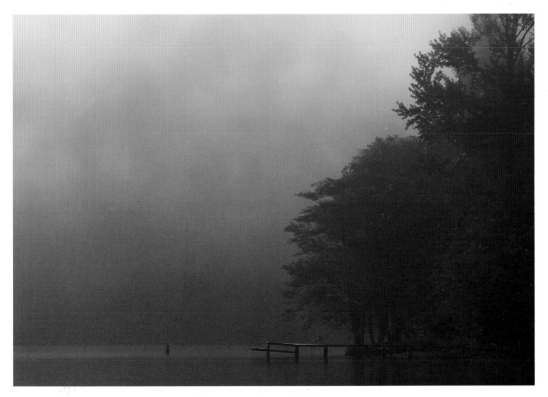

Foggy morning on Lake Crescent

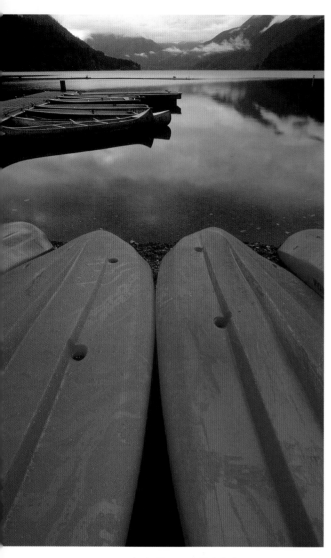

Boats at Fairholm

front of the Olympic Park Institute can add to the landscape.

Lake Crescent has a lot of potential for moody early-morning shots as well as good sunset photos. Use the pullouts along the highway. One of my favorites is **Meldrim Point (124)**, near the west end of the lake, about 1.6 miles before the Fairholm Country Store. It's not marked, but you can identify it by the relatively large pullout and the tree-covered point of land. This is one of the best spots for an overall shot of the lake. Though you could photograph here any time of the day, I think it's best first thing in the morning.

At the far west end of Lake Crescent is **Fairholm (125)**. At the **Fairholm General Store** you'll find colorful canoes for rent as well as rowboats. However, as photographers, we're more interested in photographing the canoes rather than paddling them. In the summer get here early in the morning, and use the red canoes as foreground for wide-angle landscapes. The rowboats floating next to the dock also make great subjects.

Sol Duc Hotsprings Road (126)

Different maps have different spellings of Sol Duc, some using Soleduck. Some maps even have both spellings, one spelling for the road, and one for the river. Go figure. I like the Sol Duc spelling; it's an Indian term meaning "sparkling waters," so that's what I'm using in this book.

At the west end of Lake Crescent (1.9 miles west of Fairholm, on US 101), is the Sol Duc Hot Springs Road The Sol Duc Hot Springs Road leads 14 miles up the **Sol Duc Valley** into some of the most beautiful river and forest land you'll ever see. Personally, I like the forests here better than the Hoh area. This road can be good any time of the year but is probably best in late spring when all the new growth on the trees is bright green, and the forest flowers

falls and one from near the top. Be sure to take a look at both.

While you're at Barnes Point, be sure to investigate the trail along the shore from the Lake Crescent Lodge to the Olympic Park Institute. In the summer this can be a great place to come for early-morning photography. The lake can often be shrouded in fog, with streams of light outlining the trees. A boathouse and dock in

are blooming. Vine and big-leaf maples line the road, making this a surprising fall color destination, as well.

There are plenty of places to explore along this road; the following five sites are some of my favorites stops.

Picturesque **Salmon Cascades (127)**, where the Sol Duc tumbles through large boulders, is well worth a stop. There are several options here. For the first, park in the large parking area, and walk back down the road to where you have a full view of the cascades. The shot is pretty straightforward; just be cautious of other cars as there's not much room at the side of the road. A lens in the 80mm to 200mm range works well here. Try longer exposures to capture any leaves swirling in the water, especially if you're here in the autumn.

Then from the parking area, follow the short trail to a viewing platform. From here you can go either right or left. If you walk to the right, the trail leads down to the river. It's steep in places, so be careful. From here you'll be close to the rapids. It's a good spot to come if you want to see or photograph leaping salmon. Spawning season is in the fall, so if you're here to photograph the fall color, stop by and watch the salmon.

For yet a third photo option, head left from the platform, and the trail leads to a large flat rock adjacent to the river. Use a wide-angle lens to photograph the river and forest from here.

Nine miles in from US 101 on the Sol Duc Hot Springs Road is the 0.5-mile **Ancient Groves Nature Trail (128)**, a loop that takes you through some nice forest area. Surprisingly few people seem to stop here, so you'd likely have the place to yourself. As with most forest photography, the trick here is to avoid cluttering the photo. One way to do that is by using a longer lens, like an 80–200mm zoom or 300mm. This area, as with all the forests, can be magical on misty mornings. Look for those

fingers of light that spread out when the sun backlights the trees.

Just after you pass the ranger station and the side road to the Sol Duc Hot Springs Resort (11.8 miles from US 101), you'll come to a large grove of red alder trees next to the road. In the **Hot Springs area (129)** you can park either at a maintenance building just before this spot or at a large parking lot just beyond.

I've always enjoyed attempting to create order out of chaos in forest pictures. Whether it's a stand of aspen, ponderosa pine, or these red alder, I enjoy the challenge.

The Sol Duc Trail (130) begins at the end of the Sol Duc Road. Most people hike only the first 0.75 mile to **Sol Duc Falls**, but the trail leads 8.5 miles into some of the most spectacular subalpine country you'll ever see. Since the majority of us photographers are carrying way too much gear to even think of hiking 8.5 miles, never mind the elevation gain, I'm just going to highlight the area between the trailhead and the falls.

The Sol Duc Trail to the falls is a relatively easy walk through a magnificent old-growth forest mainly consisting of Douglas fir, Sitka spruce, and western hemlock. Along the way— though mainly in the springtime, early May and into June—you'll also find lots of forest flowers. Some of the flowers you'll see include western trillium, queen's cup, wood nymph, bunchberry, and a variety of saxifrages.

About halfway to Sol Duc Falls you'll cross a foot bridge over a tumbling stream. This used to be one of the best places to photograph moss-covered boulders with a forest stream. It was simply magnificent. Then a few years ago heavy rains filled this little stream, scouring the moss from the rocks. It's now a rather pathetic looking trickle compared to its former self.

But there is a silver lining. Because that scene no longer makes for a good photograph, I looked around for an alternative. As you cross

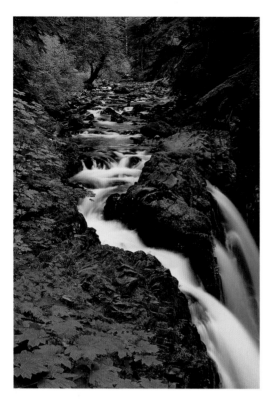

Sol Duc Falls

just as you walk onto the bridge. Use a wide-angle lens and the big green leaves of the devil's club as a foreground. Later in the summer, the devil's club sports bright red berries.

One of my favorite places is on the far side and a little upstream. When you cross the bridge, turn left to a viewing area with a rail fence. Walk to the far end where the fence ends. Just below you is a tree with room beside it for one photographer. From here use a wide-angle lens to take in the falls and the bridge. Use the foliage in front of you as a foreground, and choose a small aperture opening for lots of depth of field. You'll also want to use your polarizer to cut glare from the wet rocks and help the color of the greenery to show. This will leave you with a slow shutter speed, so a sturdy tripod is essential.

Pro Tip: Bring a red jacket along with you. If you're shooting with a friend, take turns wearing the jacket and standing on the bridge for each other's shots.

Rialto Beach (132)

A favorite destination for tide-pool photography on the coast, Rialto Beach is also a good location for sunsets and moody, fog-soaked landscapes. In fact, sunrise can be rather nice here, as well. Mist often clings to the trees, and as the sun comes up, bands of light reach from the trees to the beach.

All the good stuff at Rialto Beach is about 1 mile north of the parking area. The hike is an easy beach walk. There is one place where you'll need to cross a stream. Often you can just pick your way across near where the stream enters the ocean. Sometimes you'll need to use the nearby log bridge (which may or may not be there, depending on winter storm activity).

Beyond this area you'll find rock formations and **Hole in the Wall**, a large sea stack with, well, a big hole in it.

the footbridge, stop and turn around. The backlit leaves of a vine maple branch overhang the end of the bridge. Using a wide-angle lens, you can make an image with the branches and the bridge leading your viewer's eye along the trail and into the forest. It's a great scene.

For most visitors to the Sol Duc Valley, **Sol Duc Falls (131)** is *the* destination. This highly recognizable waterfall often serves as the "poster child" for Olympic National Park. It's easy to get to and not too far of a walk. On a summer weekend the place can be packed. Your best bet is to visit midweek and early in the morning. Ideally, you'll visit on a rainy or at least a cloudy day. This has two advantages: The light is great, and the tourists are scarce.

There are a number of vantage points from which to photograph the falls. A good spot is

Just beyond Hole in the Wall, a trail climbs the bluff. Follow this trail for just a short distance to a view from above the beach looking south. This is a good place to set up midmorning while the sunlight is still illuminating the eastern side of the rock formations. Use a wide-angle to normal lens, and be sure to bring your polarizer.

Directions: From Forks, drive north 1.6 miles on US 101. Turn left onto SR 110, and follow the signs to the Olympic National Park, Rialto Beach. Park in the large lot, and follow the trail north to the beach.

Hoh Rainforest (133)

Since the Hoh Rainforest gets about 150 inches of annual rainfall, don't be surprised if you get a little wet on your visit. In fact, you should *hope* for a little rain. Photographing forests in the rain can be a rewarding experience. For one, you'll come away with some great photos. For another, there's something very peaceful about being in the forest during rainfall (to a point).

You'll want to investigate a couple of trails here. The 0.75 mile **Hall of Mosses** loop trail is the most popular and also the best known. Many pictures you see of the Hoh Rainforest are made right here. The wide trail is actually rather attractive and acts as an effective leading element. Some hotspots will invariably creep in if you include much of the forest canopy. Just be aware of these and do what you can to minimize them by changing your composition or your shooting position. Also, and sing along if you know this one, be sure to use a polarizer.

The **Spruce Nature Trail** is 1.25 miles round-trip and has several examples of nurse logs—a hallmark of old growth—for you to photograph. Also look for ferns, mushrooms,

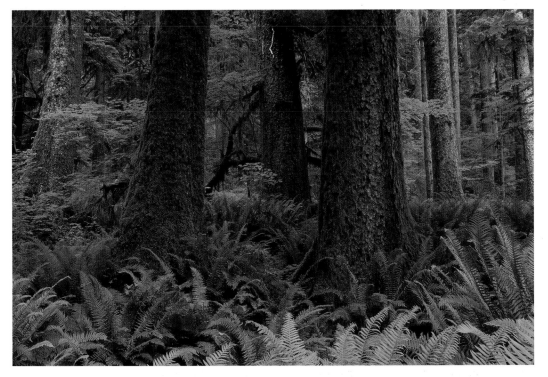

Hoh Rainforest

and undergrowth plants such as wood sorrel (or oxalis) and vanilla leaf.

Pro Tip: The trees here are huge. Have someone stand in the trail next to a tree to add some scale to your pictures.

Pro Tip: Using a wide-angle lens here can be tough. One way to help control the chaos is to find a strong foreground (like a large fern), and fill most of the frame with it. You'll need to get close to your chosen foreground for this to work.

Directions: From Forks, follow US 101 approximately 13 miles south, and turn east onto Upper Hoh Road. You'll see the large sign directing you to the national park. The Hoh Rainforest Visitor Center is at the end of Upper Hoh Road, approximately 18 miles.

Ruby Beach (134)

Ruby Beach is one of the most photogenic beaches on the coast and one of the easiest to get to. You'll find several picturesque sea stacks, some tide pools, and probably lots of company. From the parking lot, follow a short trail through the forest down to the beach. If you

Rocks on Ruby Beach

plan on photographing the sunset, consider bringing a flashlight to find your way back.

Pro Tip: The rock formations here make great silhouettes against a sunset sky. Be sure to check your composition to make sure that the areas that will go black in the final image don't merge with each other to create confusing blobs.

Directions: Ruby Beach is about 26 miles south of Forks on US 101.

Queets Corridor (135)

Queets Road follows a narrow corridor of Olympic National Park to its end 13.6 miles from US 101. The trees along this road are huge; some of them in the campground, near the end of the road, measure greater than 10 feet in diameter.

There's no real trick here. Drive along until you find something you particularly like, or just park somewhere along the road and walk around.

Directions: Queets Road is 47 miles south of Forks on US 101 and about 18 miles west of Lake Quinault.

Lake Quinault (136)

Surrounded by forested hills and often shrouded in mist, Lake Quinault is one of the more remote places on the peninsula. Access to the lakeshore is limited, though there are two campgrounds and a picnic area along South Shore Road. If fog or low lying clouds blanket the lake, you can get some shots with a very moody feel to them. The Lake Quinault Lodge makes for a great getaway as well as a good photo subject. Just wander the lawn on the lake side of the lodge and look for good vantage points. From the lodge, you can explore into Olympic National Park by taking either the South Shore Road or the North Shore Road. The South Shore Road leads to the Graves Creek campground. You can stop just about

anywhere along here to photograph the forest. The **Graves Creek Nature Trail** begins at Graves Creek campground. It's a 1-mile loop trail through the rainforest. You can take North Shore Road by either crossing over to it from South Shore Road or by starting on US 101. North Shore Road leads to the North Fork Quinault trailhead. The road goes through some beautiful rainforest, ending at the ranger station near the campground. From here you can follow the North Fork Trail for about 2.5 miles to Wolf Bar, a backcountry campground in a nice stand of alder and fir next to the river. This is a real nice place in a light drizzle.

Directions: Lake Quinault is located on the south side of the park. From Interstate 5 take exit 88B (south of Olympia) to US 12. Follow US 12 for 46 miles to Aberdeen, and follow the signs to US 101 northbound. Lake Quinault is approximately 42 miles north. Turn right at South Shore Road. North Shore Road is 3 miles west of South Shore Road on US 101.

Staircase (137)

The east side of Olympic National Park is not as accessible as the north and west sides. All of the trails follow rivers and cross streams, so there's plenty to photograph if you can get to it. One area that has pretty good access is the **Staircase** area on the south east side of the park.

From the ranger station, there are two trails to choose from, the **Staircase Rapids Trail** and the **North Fork Skokomish River Trail**. Either one will lead to good views of the river and the Staircase Rapids. There was a time that these two were connected by a bridge, making for a possible 2-mile loop trip. But several years ago the bridge was washed out and has yet to be replaced; I'm not sure it ever will be. Also look for forest flowers like trillium, bunchberry, and calypso orchid. A little over a

Calypso orchid along North Fork Skokomish Trail

mile up the Staircase Rapids trail you'll come to a campground next to the river. In the spring and early summer this is an excellent spot to find colorful harlequin ducks. If you follow the North Fork Skokomish Trail, you can photograph the Staircase rapids from the other side of the river. Just past the junction trail leading to the washed out bridge you'll come to an area along the trail where, during early May, I've always found the beautiful calypso orchid.

Directions: From Interstate 5 in Olympia take exit 104 to US 101. Follow US 101 north toward Port Angeles approximately 36 miles to the town of Hoodsport on the Hood Canal. Turn left (west) on North Lake Cushman Road (SR 119) and follow about 16 miles to its end at the Staircase ranger station.

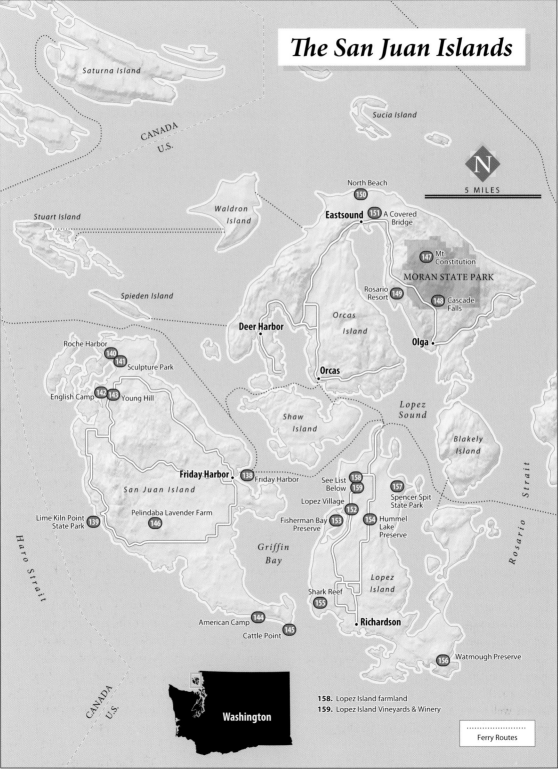

The San Juan Islands

Saturna Island

CANADA
U.S.

Sucia Island

N

5 MILES

North Beach
150

Stuart Island

Waldron Island

Eastsound 151 A Covered Bridge

147 Mt. Constitution

MORAN STATE PARK

Spieden Island

Rosario Resort 149 148 Cascade Falls

Orcas Island

Deer Harbor

Olga

Roche Harbor
140 141 Sculpture Park

Orcas

Lopez Sound

English Camp 142 143 Young Hill

Blakely Island

Shaw Island

Friday Harbor 138 Friday Harbor

See List Below 158 159

157 Spencer Spit State Park

San Juan Island

Lopez Village

152

Lime Kiln Point State Park 139

Pelindaba Lavender Farm
146

Fisherman Bay Preserve 153 154 Hummel Lake Preserve

Rosario Strait

Haro Strait

Griffin Bay

Lopez Island

Shark Reef
155

Richardson

American Camp 144
Cattle Point 145

156 Watmough Preserve

CANADA
U.S.

Washington

158. Lopez Island farmland
159. Lopez Island Vineyards & Winery

Ferry Routes

Paul Woodward, © 2007 The Countryman Press

VI. The San Juan Islands

SPRING ★★★ SUMMER ★★★★ FALL ★★★ WINTER ★

The San Juan Islands have been called the "Gem of Washington State." They certainly are rare and precious. Located between Vancouver Island and the mainland of Washington, the San Juan archipelago includes some 172 named islands, 30 of which are inhabited. The three largest and most accessible islands—and the reasons I'll highlight them—are San Juan, Orcas, and Lopez. These three islands offer a wide variety of photographic opportunities from harbors, lighthouses, and posh resorts to waterfalls and whales. You'll find stunning views and equally stunning sunsets. There are tourist towns as well as pastoral farmland. In short, just about anything an outdoor or travel photographer could ask for.

The easiest way to travel to the San Juan Islands is by ferry. The Washington State Ferry System serves four of the islands: San Juan, Shaw, Orcas, and Lopez. Ferries leave from Anacortes several times a day, bound for different islands. You can access the ferry schedule by going to www.wsdot.wa.gov/ferries.

To get to the Anacortes ferry, travel north from Seattle, and take the SR 20 exit (exit 230) west to Anacortes. Follow the signs to the ferry.

The first thing you might notice is that life in the San Juan Islands seems to be slower and more relaxed. It doesn't take a long time to get from place to place, making scouting your shots a lot easier. But these are small islands, and it's hard to get yourself lost. Just be sure to pick up the tourist maps, and you'll be fine.

San Juan, Orcas, and Lopez each have their charms. San Juan boasts one of the premier whale-watching sites in Lime Kiln Point State Park as well as a National Historic Park, resort towns, and a lavender farm. Orcas has the spectacular Moran State Park, and Lopez has farmlands, harbors, and a great vineyard/winery.

A note on accommodations: Summer is the best time to visit the islands, but that's also when they're the most crowded, so you'll want to book a place to stay early. Camping is also available. Camping reservations and information for Washington state parks (Moran State Park on Orcas and Spencer Spit State Park on Lopez) can be found at www.parks.wa.gov or by calling 888-226-7688. Information on San Juan County Park camping is available at www .co.san-juan.wa.us/parks. Reservations may be made by calling 360-378-1842.

San Juan Island

San Juan Island is the second largest of the San Juan Islands and home to half the residents. Here you'll find some of the best whale watching in the country as well as a national park.

Friday Harbor (138)

Friday Harbor is where the ferry docks and your first stop on San Juan Island. I suggest finding a parking spot and taking a walking tour of the town. It's not large, so it won't take you long. A visitors center is on the east side of Spring Street (the main street in town) just south of First Street, where you can pick up maps and such.

Friday Harbor is great for the travel photographer in you. I suggest walking around with a wide-angle zoom and perhaps a lens in the 24mm to 120mm range, and see what catches your fancy. A good place to start is Spring Street Landing, right next to the ferry dock. Then follow Front Street west to the marina. This would be a good spot for early-morning

photography, whether you get the warm light of sunrise or the mystery of a foggy morning. It's a public marina, so wander out around the boats looking for reflections, nets, or any other nautical tack that catches your eye.

Near the end of Front Street is a stairway, flanked by large boulders and colorful poppies, that leads to First Street close to the Whale Museum. The Whale Museum, though not necessarily a photo stop, is well worth the visit.

Just east of the Whale Museum on West Street is a small public park overlooking the marina and ferry dock. It's a good place to photograph ferries coming and going. This would also be a good place to set up for a sunrise shot. With any luck you'll get some good color in the sky and water, maybe even with a ferry in the middle of it all.

Lime Kiln Point State Park (139)

Want whales? How about a lighthouse? Maybe some historical buildings? Lime Kiln Point State Park has all that and more.

Whales

This is probably the premier whale-watching spot in the islands. In fact, another name for the park is Whale Watch Park. Orcas (killer whales) often come very close to the rocky shores. There's plenty of parking, an information center, and restrooms. Follow the trail from the lower parking lot to the whale-viewing platforms. The trail continues on to the lighthouse, and, really, anywhere along here is good for whale viewing.

Though there are resident pods, summer is still the best time for sighting whales. And while this is a great place to see whales, they are usually on their own schedule. They're most often seen between about 9 AM and 5 PM. Or so. Sometimes you just have to get lucky. Chances are that if you hang around most of a morning or afternoon, you'll see whales. The most recent sightings are posted at the lighthouse, which also serves as an interpretive and whale-research center. The staff here can often

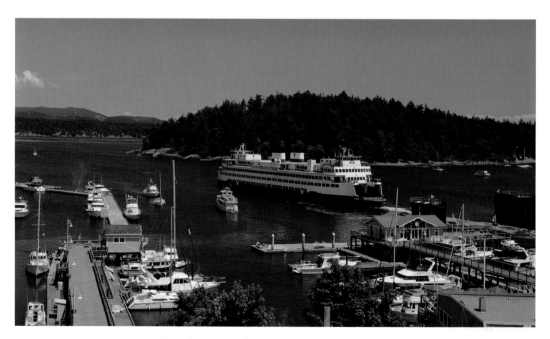

Ferry leaving Friday Harbor, San Juan Island

give you an idea of when whales may be by again.

Since you're facing roughly southwest the best light for whale photography from the shore is often in the morning.

Since the whales can come quite close to shore, you don't need a monster lens to get good pictures—a 300mm lens with or without a teleconverter will do the job. You'll definitely want to be on a sturdy tripod, too.

But you'll need patience to photograph orcas. Just because they're visible doesn't mean they'll come close to shore. And just because they're out of the range of your lens for the moment doesn't mean they won't eventually come closer. So just wait, enjoy the scenery, and see what happens.

Another good site is just 0.8 mile south of Lime Kiln Point State Park—a pullout at the **Westside Preserve Viewpoint**. A short trail leads toward the water. The water offshore is very deep and, like Lime Kiln Point, the whales come very close to shore.

For a chance to get even closer to the whales, take a whale-watching trip from one of the many tour operators in Friday Harbor and Roche Harbor as well as on Orcas Island.

Pro Tips: Whales, though seemingly slow, are actually moving as quickly as any other wildlife, so fast shutter speeds are needed. I'd recommend at least 1/250th of a second—faster if you can manage it.

Good whale photography takes a little practice and some time observing whale behavior. You have to react fast to get them in the viewfinder before they go below the surface. With any luck you'll capture some great behavior like spy hopping or fin splashing or belly whopping.

The Lighthouse

Besides the whales, you've got the very picturesque **Lime Kiln Point Lighthouse** in a very picturesque setting. You should probably take some pictures. You can photograph the lighthouse from either the north or south side, though there are more possibilities on the south side. The lighthouse makes for a good postcard shot from the south side in midmorning. After that, the light will get too harsh until sunset, when the best light arrives.

There are so many good vantage points from which to photograph the lighthouse that you couldn't exhaust them all in a week of sunsets. From the north side, you can use a madrona tree, the rocky shore, or flowers growing out of the rocks as foreground elements in a wide-angle landscape.

From the south side, you'll find several different vantage points along the trail. Try using some of the overhanging trees as framing elements.

If you are here in the summer, you'll be sharing the location with a few (probably more than a few) others. You may not be able to photograph the lighthouse without any people near it. Just go with it. If you're photographing the lighthouse as a silhouette, the people will also be silhouettes. In other words, they'll just be black shapes in the frame. Watch how these shapes merge, and wait until there is good separation or interesting poses.

Old Lime Kilns

Though not really all that photogenic, the old lime kilns are historically interesting buildings and help tell the story of San Juan Island. Simply follow the trail behind the information center approximately 0.2 mile to an overlook of a restored lime kiln. Late afternoon with its warm light would be a good time to photograph here. An overcast day would work well, too.

Directions: From the ferry dock in Friday Harbor, turn left on Spring Street and then right on Second Street. Second turns into Guard Street and then Beaverton Valley Road,

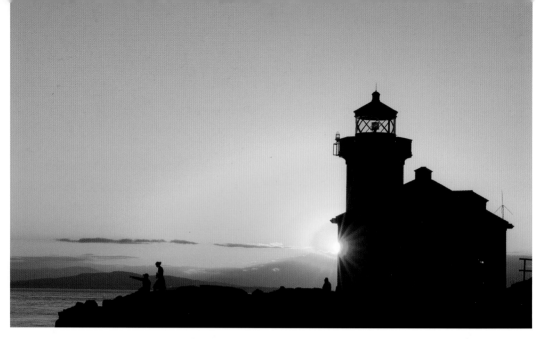

Lime Kiln Point Lighthouse on San Juan Island

which turns into West Valley Road. About 7 miles from the ferry dock, turn left on Mitchell Bay Road, then left again in 1.3 miles at Westside Road. Follow Westside Road south approximately 4.3 miles to the entrance of Lime Kiln Point State Park. (If you happen to be camping at San Juan County Park you'll come to it about 2.5 miles before the state park.)

Roche Harbor (140) and Westcott Bay Sculpture Park and Nature Reserve (141)

Roche Harbor is on the north side of San Juan Island and is known as a destination resort. It boasts the Hotel de Haro, which is on the National Register of Historic Places, and this is reason enough to come photograph. The white-clapboard hotel overlooks a wonderful formal garden that's often used for weddings. You'll find plenty of foreground material for wide-angle pictures of the garden and hotel as well as close-up subjects for macro photography enthusiasts. For your landscape shots, be sure to try a polarizer to cut the sheen off the plants plus help the sky. On a sunny day you

may end up with some shadows in your foregrounds. Here's where a reflector or fill-flash can save the day.

In front of the hotel is the marina and the general store. Walk out on the marina dock for good shots looking back at the hotel.

Just as you get in to Roche Harbor you'll see the **Westcott Bay Sculpture Park and Nature Reserve**. This is a rather unique place in that along its trails you'll encounter several different environments, including open prairies, salt marshes, forest, freshwater ponds, and rocky outcropping. These diverse ecosystems are home to a variety of plant and animal life. But the unique feature of this place is the over one hundred stone, wood, and metal sculptures by regional artists on display throughout this 19-acre park. For more information, go to www.wbay.org.

Directions: From the ferry dock in Friday Harbor, turn left on Spring Street and then right on Second Street. Second turns into Guard Street. Turn right on Tucker Avenue,

which will turn into Roche Harbor Road. Follow this road approximately 10 miles to Roche Harbor.

English Camp (142) and Young Hill (143)

Part of San Juan National Historic Park, **English Camp** is a good place to get photos of historic buildings, a formal garden, and a stunning view. From the parking area, pick up a map at the informational sign. If you follow the main trail downhill, you'll come to a visitors center.

Continue toward Garrison Bay, and on your left you'll see a formal garden enclosed by a white-picket fence. (This in itself is fun to photograph.) You can either use your close-up lens for flower portraits, or you can use the garden as foreground material for wider landscapes. From inside the garden, look for lines and curves that can act as leading elements. Background options include the bay and the big maple tree with the visitors center. From here you can see a trail that switchbacks uphill to where the officers' quarters used to be. About halfway up this trail is a good vantage point for a more aerial view of the gardens.

From the east end of the parking lot, follow the trail through a nice-looking forest to the top of **Young Hill**, and would be great to photograph on an overcast or rainy day. The trail crosses the West Valley Road and continues past the English Camp cemetery on to the top of 650-foot Young Hill. The 0.75-mile trail is moderately steep, so you probably won't want to haul a 50-pound camera pack to the top.

The view from the top is worth the hike, though. With Garrison Bay and Westcott Bay directly below and Henry Island beyond, the view faces west toward Haro Strait and Vancouver Island, making this location more of a late-afternoon and sunset spot, though early morning would certainly be nice, as well.

This is a place where you could actually use almost all of your lenses. But in the interest of cutting down on the weight of your pack, I'd suggest a wide-angle zoom lens and a light-weight zoom lens in the 70–300mm range.

Directions: From Friday Harbor, follow directions to Lime Kiln Point State Park, but instead of turning on Mitchell Bay Road, continue on West Valley Road about another 1.5 miles to the park entrance.

American Camp (144)

American Camp is part of the San Juan National Historic Park. Though not as interesting photographically as English Camp, it's nevertheless worth the stop. This is a historically interesting place since near here is the site where the Pig War almost started, which led to both American and English Camps. Two original buildings are left: officers' quarters and laundress's quarters. A white-picket fence surrounds the grounds around the officers' quarters and makes for a decent foreground. Zigzagging split-rail fences bordering the trails can be used for foregrounds. These trails lead to overlooks and to the site of old fortifications. Here you have a good view of the distant Olympic Mountains.

Directions: From Friday Harbor, follow directions to Lime Kiln Point State Park, but instead of turning on Mitchell Bay Road, continue on West Valley Road about another 1.5 miles to the park entrance.

Cattle Point (145)

If you continue driving past the entrance to American Camp you'll come to Cattle Point. About 1.7 miles past the South Beach road, look for a pullout with interpretive signs on the right. You'll be able to see the **Cattle Point Light** from here. The whole area is crisscrossed with trails, and it's obvious that others have been out in the meadow. But there are small, faded, and hard-to-see signs stapled low

on an already low fence requesting that you do not enter this sensitive breeding area. Frankly, I didn't even notice these signs until I was getting ready to leave.

Park here, and walk back up the road to the big American Camp sign. Here, a split-rail fence denotes the boundary of National Park Service managed land. It's also a good place to photograph. In summer the meadow is covered with orange poppies that can make a very attractive foreground. The fence, surrounded by poppies, also makes for a good foreground.

From this vantage point, you're standing above **South Beach**, with the cliffs and beach curving away to the point. A lens in the 28mm to 70mm range works well here.

Directions: From the ferry dock on Friday Harbor, follow Spring Street, which turns into San Juan Valley Road. At about 1.7 miles, turn left (south) onto Douglas Road. After another 0.75 mile, turn left on Madden Lane. Madden will turn into Cattle Point Road. The park entrance is about 4.4 miles from where you turned on Douglas Road.

Passing the park entrance will take you to South Beach and Cattle Point.

Pelindaba Lavender Farm (146)

Lavender farms are some of my favorite places to photograph. I just can't get enough of the colors and patterns, and this small farm in the middle of the island should be on your list of places to visit. A very nice gift store has everything lavender you could imagine, including dog treats. Be sure to try some of the lavender ice cream.

Photographically, you'll find an old piece of farm equipment in the middle of the fields and plenty of close-up and landscape opportunities.

The store is open 10 to 5 daily May through September and Wednesday through Sunday in

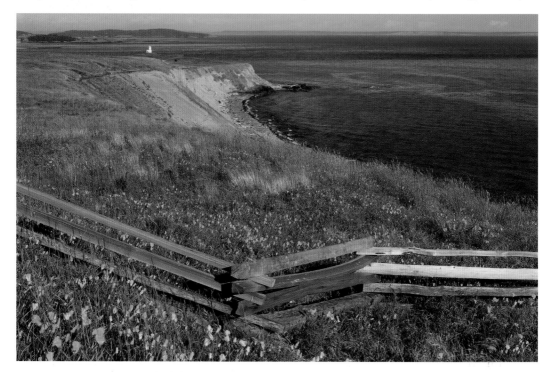

Bluff above South Beach and Cattle Point Lighthouse

the fall and winter months. The fields are open at any time. The owners just ask that you close the gate behind you.

Directions: From Friday Harbor, follow directions to Lime Kiln Point State Park. Once on Beaverton Valley Road, turn left onto Boyce (approx. 4.6 miles from ferry dock). In one mile turn right onto Wold. The lavender farm is about 1.8 miles on the left. For more information: www.pelindaba.com.

Orcas Island

Orcas Island is the largest of the San Juans. One of the most popular resorts, Rosario, is located here, as is the highest point in the islands: Moran State Park's Mount Constitution.

Moran State Park

Moran State Park boasts the best view in the San Juan Islands from atop Mount Constitution as well as a few waterfalls and steams, a couple of lakes, lots of hiking trails, and some nice forested areas.

The steep and winding road to the top of **Mount Constitution (147)**, the highest point in the San Juans, has several pullouts with excellent views of their own. The only real problem with photographing from Mount Constitution is that you can't photograph there at sunrise in summer unless you hike to the top. You see, the gate to Mount Constitution Road isn't opened until well after sunrise in the summer. It's too bad because I think that sunrise would be spectacular from there. In the summer the road opens at 6:30 AM. In mid-September that opening changes to 8 AM. In mid-April, the road will again be opening at 6:30 AM. So the closest you'll be able to get to sunrise is in late August to mid-September.

The view from the top looks north and west and south, with Mount Baker and Bellingham to the northwest and Mount Rainier to the

Lavender at Pelindaba Lavender Farm

south. At midday in summer the haze can be so bad that you can't make out Rainier. It's really no time to photograph, so just enjoy the view and plan on coming back for sunset. With any luck, Mount Baker will light up, and any color in the sky will reflect in the water below. Use the midday hours to scout the viewpoints and plan your dinner.

Be sure to check out the other viewpoints along the road. There are good places to get photos that will have it all: water, islands, mountains, and ferries.

About a quarter mile up Mount Constitution Road is the trailhead to **Cascade Falls (148)**. The trail itself is relatively easy—only about 0.25 mile long and losing just 130 feet in elevation. Well worth the stop, the 75-foot-tall Cascade Falls is easily accessible. Like most all waterfalls and streams, Cascade Falls is best photographed on an overcast day. But if you're stuck with fair weather, visit either midmorning or late afternoon, when the surrounding terrain will shade the area of the falls. The falls look best in spring and early summer when water runoff is highest.

Directions: To reach Moran State Park from the ferry dock, follow Orcas Road to the town

Mount Baker at sunrise from North Beach

Rosario Resort (149)

Rosario is the largest resort in the San Juan Islands in one of the most picturesque settings. Sunrise is a good time to capture the feeling of relaxing stillness that the islands can engender. In the summer the sun will crest the hills at around 7 AM, but get there well before then. Midmorning is a good time for some travel or postcard-type shots.

Park near the front of the Moran Mansion, the main hotel at the resort, and follow a sidewalk to the water side of the hotel. Here you can use a wide-angle lens to include the sidewalk, flowers, and deck, with the calm waters of Eastsound as the background. Try using tables and chairs on the deck as "place-setting" foreground. If you've got traveling companions or fellow photographers with you, have them sit at the tables to add the human element.

Directions: On the way to Moran State Park, turn right at the sign for Rosario Resort (approximately 3 miles from Eastsound). Follow Rosario Road to the resort.

North Beach (150)

Since Moran State Park isn't the best place for sunrise, how about North Beach for a stunning view of **Mount Baker** plus **Sucia, Matia,** and **Patos Islands**. If the tide is high, you may not get a clear view of Mount Baker as it will be partially hidden by a point that juts out just east of where you'll be. Near the solstice, the sun comes up right behind Matia Island.

Telephoto lenses work well here to isolate either Mount Baker or islands below the rising sun. A note of caution: Though this is a public-access beach, it's a very narrow public access. Be aware that the areas both east and west are private.

Directions: It's very easy to get here. From the Mount Baker Road, turn north on North Beach Road, and follow to its end. North

of Eastsound (approximately 8.5 miles). Here you can opt to go through Eastsound to visit the shops or pick up supplies and then connect with Olga Road on the east side of Eastsound (the only real town on the island) and continue south another 3 miles to Moran State Park. Or you can follow the signs to Moran State Park and bypass Eastsound by taking Mount Baker Road, just to the north of town. Either way gets you there.

Beach Road is just east of the Orcas airport and is the road used to bypass Eastsound on the way to and from Moran State Park.

Covered Bridge (151)

On Mount Baker Road, about 0.8 mile east of North Beach Road, you'll see a covered bridge on a private drive in a field on the north side of the road. This is on private property, but it can be photographed from the road. It's easy to find—it's right across the street from Orcas Power & Light, which is a handy place to park. This is a good place to stop after photographing sunrise at North Beach.

Lopez Island

Sometimes called "Slowpez" for its laid back, easygoing pace, Lopez Island is a bit different from the others. For one, the island is flatter, making it very attractive to bicyclists. It's smaller, as well. It probably takes less that 20 minutes to get to anywhere from anywhere. You'll find picturesque farmland, harbors, a winery, dramatic shorelines, and a lot of friendly people. I read in a guidebook that it's customary for the locals to wave at passersby. I figured that was guidebook hype, but when I visited Lopez I found it to be true.

Lopez Village (152)

Lopez Village is small. It won't take you long to explore and find some vantage points for sunset, which can be fantastic here. (Actually, the few minutes *after* the sun sets is when colors can get really intense.) Take a look around, and see where some of the boats are "parked" in Fisherman Bay and whether they will make for good silhouettes come sunset.

Since boat positions change on a daily basis and the sun sets at different places throughout the year, there isn't any one particular place to set up all the time. Use a compass to determine where on the horizon the sun will set.

One place I will mention is the parking lot of The Bay Café on Old Post Road, just off Lopez Road between Tower and Weeks Roads. Here you'll find a sort of viewing platform with stairs leading to the beach. This is also a great place to view ferries coming and going from Friday Harbor.

Be sure to wander around Lopez Village. The **Lopez Historical Museum** is full of interesting subject matter.

Directions: From the Lopez ferry dock, follow Ferry Road, and in 2 miles turn right onto Fisherman Bay Road. Fisherman Bay Road will turn to the left, but keep going straight onto Military Road. Military Road will run into Lopez Road. Follow Lopez Road into the village. You could also follow Fisherman Bay Road, turning at Weeks Road, to get to the village.

Fisherman Bay Preserve (153)

Have you ever looked at a map and said to yourself, "I wonder if I can get to that spot. It looks like there'd be a great view from there"—only to find that you really can't get to that spot because it's all private property. Well, this is one of those places on the map that looks like it would be good and you *can* get to it. Fisherman Bay Preserve is part of a group of Land Bank acquisitions set aside for preservation of natural beauty and public access.

From the parking area (where there's a restroom), follow the trail mowed in the grass to a vantage point overlooking Fisherman Bay and Lopez Village. This is a good spot to photograph moored sailboats and the village lit with the warm light of late afternoon. A lens in the 80mm to 200mm range works well for photographing the boats and the village as well as any kayakers who may be tooling about the bay.

When the light here begins to fade, pack up your gear and make your way back over to Lopez Village, where you previously scouted your preferred sunset site.

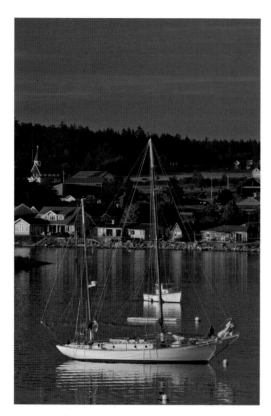

*Fisherman's Bay and Lopez Village,
late afternoon*

Directions: From Lopez Village, take Fisherman Bay Road to Bayshore Road. Turn right, and follow Bayshore around the bay approximately 1.3 miles to Peninsula Road. Turn left onto Peninsula, and in about 0.7 mile turn right at the Fisherman Bay Preserve sign. (By the way, Bayshore Road makes for a good sunset spot, too. Ahhh, so many sunset spots, so little time. . . .)

Hummel Lake Preserve (154)

Another Land Trust location, Hummel Lake Preserve is a good location for sunrise, water lilies, and birds. If you're after a sunrise, you will want lenses in the wide-angle to short-telephoto range. For water lilies it really depends on how close you can get. A 300mm lens with an extension tube and maybe a teleconverter would be my choice for photographing things that are just out of range of my macro lens. If you're after birds, bring your longest telephoto and some patience.

From the parking lot, follow the short trail (which starts right next to the restroom) to a boardwalk that will bring you to the water's edge. The boardwalk moves a bit, so choose shutter speeds that will eliminate any movement. Be aware of others walking on the boardwalk, as well.

Directions: Take Hummel Lake Road to Center Road. Turn right (south) onto Center. The parking lot is about 0.25 mile south on your left. From the ferry dock, follow Ferry Road as it turns into Center Road. Hummel Lake Road is 4 miles from the ferry.

Shark Reef (155)

Shark Reef is known for its rugged and scenic coastline with views of the Olympic Mountains and the Cattle Point Lighthouse, old-growth forest, and wildlife. It's a well-known haul-out point for seals and sea lions, too, so you might want to bring your longer lenses. A 300mm or so should do. But please, for your safety and theirs, don't approach the pinnipeds! The trail to Shark Reef is an easy quarter mile or so. Longer if you continue south along the coastline, and why wouldn't you? There's plenty to explore.

Shark Reef is an excellent late afternoon/sunset location since it faces southwest and will catch the last light of the day. To the west is the **Cattle Point Lighthouse** on San Juan Island. Use an 80mm to 200mm lens to frame it against the sky.

Facing south, the shoreline makes for good foreground material with the Olympic Mountains in the background. Follow the "trail" south for a good view of **Deadman Island**, just offshore.

Cautions: This is a rugged shoreline, with uneven terrain and slippery rocks. Please exercise care, and wear sturdy walking shoes.

Directions: From Lopez Village, follow Fisherman Bay Road south. Turn right onto Airport Road and then left onto Shark Reef Road. The parking area is on the right in about 1.7 miles. The trailhead is on the left-hand side of the parking lot.

Watmough Bay Preserve (156)

This is another Land Trust site. It seems that any Land Trust location you happen across is good for photography. The flat 0.25-mile trail leads to the northwest facing **Watmough Bay**. One of the first things you'll notice is Mount Baker looming above the water. Sailboats are often moored in the bay, making this calm and peaceful place excellent for sunrise photography. By using a long lens, you can photograph one of the sailboats with Mount Baker seemingly huge in the background.

Directions: Take Center Road south, and turn left onto Lopez Sound Road. In 0.25 mile turn right onto Mud Bay Road. Follow Mud Bay Road until it intersects with Aleck Bay Road in about 4 miles. Turn right, and follow Aleck Bay Road for 0.5 mile. Here, Aleck Bay Road turns sharply to the right, and Watmough Head Road continues straight. Follow Watmough Head Road for 0.9 mile, and turn left at the sign for Watmough Head Preserve. The trail is a blocked-off continuation of the road, and there's a restroom in the parking lot.

Spencer Spit State Park (157)

Spencer Spit is a popular park for camping, beachcombing, and bird-watching. There are also some good photographic opportunities here. For landscape photography, early morning and late afternoon are the best times to photograph picturesque ferry boats as they make there way to and from Anacortes. With the ferries' interior lights ablaze, twilight can be one of the best times to photograph them.

From the day-use parking lot, follow the trail down to the spit. Continue north past the lagoon to just before you get to the walk-in campsites. The beach here is a good place to set up and wait for the ferries to go by. Consult the ferry schedule to best time sunset or sunrise with a passing ferry.

Directions: From the ferry dock, follow Ferry Road for about 1.2 miles, and turn right onto Port Stanley Road. In 2.4 miles turn left onto Bakerview Road. Take Bakerview to the park entrance, and follow the signs to the day-use parking area. Spencer Spit State Park is closed November though February

Lopez Island Farmland (158)

Just driving around the island, you'll see lots of pastoral farmland scenes. I'll get you started with a good site for early-morning photography. Follow the directions toward Lopez Village State Park. On Military Road, just south of where Fisherman Bay Road turns south, is Carmen's Cottage B&B. Right across the street is some nice farmland with some poplar trees across the field and the harbor and Olympic Mountains beyond. If you're lucky, there will even be a cooperative cow willing to pose.

Since you need to be there early in the morning, parking on the side of the road shouldn't present a problem, but turn on your hazard lights just in case, or try parking in front of the gated driveway.

Lopez Island Vineyards and Winery (159)

A vineyard, a flower garden, and wine tasting: all the ingredients for creative photography. Visit www.lopezislandvineyards.com for more information.

Directions: About 1 mile north of Lopez Village on Fisherman Bay Road. The vineyard will be on the west side of the road.

Suggested Reading

If Washington has anything, it's lots of guide books. Tourism and outdoor recreation are both big here, so there's lots of help out there for you. Here are a few that have helped me:

A Waterfall Lover's Guide to the Pacific Northwest by Gregory A. Plumb (Mountaineers Books, 1998)

Exploring Washington's Wild Olympic Coast by David Hooper (Mountaineers Books, 1993)

Fodor's Seattle's Best by Suzanne Tedesko (Fodor's Travel Publications, 2004)

Garden Touring in the Pacific Northwest by Jan Kowalczewski Whitner (Alaska Northwest Books, 1993)

Nature in the City: Seattle by Maria Dolan and Kathryn True (Mountaineers Books, 2003)

Olympic Mountains Trail Guide, third edition, by Robert L. Woods (Mountaineers Books, 2000)

San Juan Islands by Don Pitcher (Moon Handbooks, Avalon Travel Publishing, 2005)

Seattle Photo Guide Map distributed by Tom Hasletine; available at www.tomhaseltine .com

Top 10 Seattle by Eric Amrine (DK Publishing, 2005)

Washington Nature Weekends by Sunny Walter and Janet O'Mara (A Falcon Guide, Globe Pequot Press, 2001)

Washington State Parks by Marge and Ted Mueller (The Mountaineers Books, 2004)

Washington Wildlife Viewing Guide by Joe La Tourrette (Falcon Press, 1992)

Misty morning near Sol Duc Falls